Fountain Pens

PENNE STILOGRAFICHE

Alex Fortis
Antonio Vannucchi

CHRONICLE BOOKS

SAN FRANCISCO

First published in the United States of America by Chronicle Books in 1995.
Copyright © 1994 by BE-MA Editrice.

All rights reserved. No part of this book may be reproduced in any form
without written permission from Chronicle Books.

Printed in Hong Kong.

Library of Congress Cataloging-in-Publication Data:
Fortis, Alex.
 [Penne stilografiche. English & Italian]
 Fountain Pens = Penne stilografiche/Alex Fortis, Antonio
 Vannucchi; [caption translation, Joe McClinton].
 p. cm.— (Bella cosa library)
 ISBN 0-8118-1083-6 (pb)
 1. Fountain Pens I. Vannucchi, Antonio. II. Title
 III. Series.
 TS1266.F67 1995
 681'.6—dc20 94-45219
 CIP

Caption translation: Joe McClinton
Photography: Antonio Fedeli
Series design: Dana Shields, CKS Partners, Inc.
Design/Production: Robin Whiteside

Distributed in Canada by Raincoast Books
8680 Cambie Street
Vancouver, B.C. V6P 6M9

10 9 8 7 6 5 4 3 2

Chronicle Books
275 Fifth Street
San Francisco, California 94103

Fountain Pens

*F*or five thousand years, the pen has been an indispensable tool of communication, lending a certain cachet to private, social, and business life. The fountain pen, which arrived on the scene only about a century ago, reached a peak of popularity and elegance during the 1920s, when it became a true status symbol, an expression of its owner's personality, social standing, and moods.

Replaced first by the typewriter, then the ballpoint pen, and finally the computer, fountain pens have only recently come back into style, thanks in part to an increasing affection and enthusiasm among collectors for vintage pens, and in part to the beauty and versatility that fountain pens lend to life's most important and personal moments.

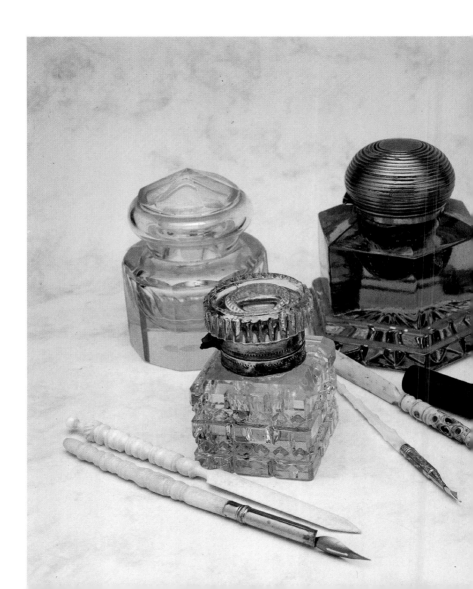

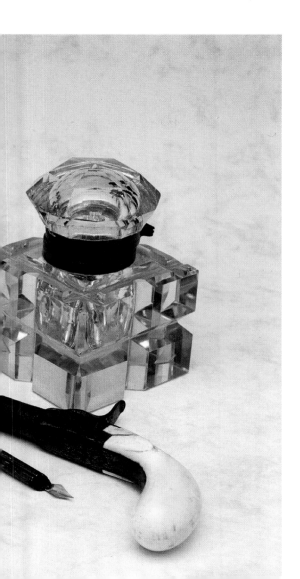

*G*reat *B*ritain and *I*taly,
1870-1900
Crystal and brass inkwells.
Bone and ivory standard pens
and letter opener.
Pocket pistol with ivory handle.

Inghilterra e Italia,
1870-1900
Calamai in cristallo e ottone.
Penne porta pennino e aprilet-
tera in osso e avorio.
Pistola da borsa con il calcio in
avorio.

France, ca. 1900
Bronze ink stand.
Ivory and mother-of-pearl standard pens and letter opener.
Six-chambered pocket revolver.

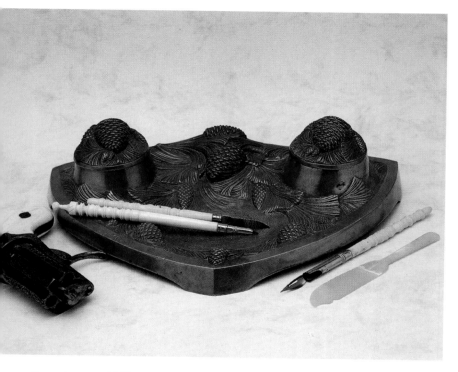

Francia, c.a. 1900

Calamaio da tavolo in bronzo.

Penne porta pennino e aprilettera in avorio e madreperla.

Pistola da tasca a 6 colpi.

*G*reat *B*ritain, *1880-1920*
Porcelain inkwells.
India, ca. 1900: Ointment pot.

Inghilterra, 1880-1920
Calamai in porcellana.
India, c.a. 1900: Porta unguenti.

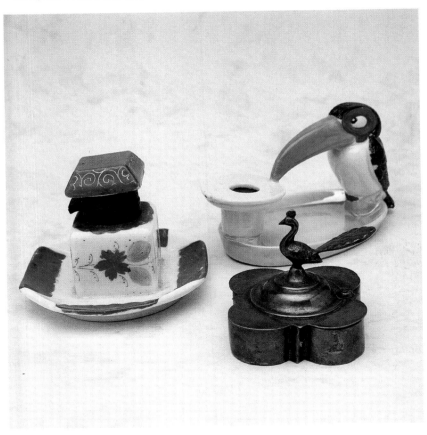

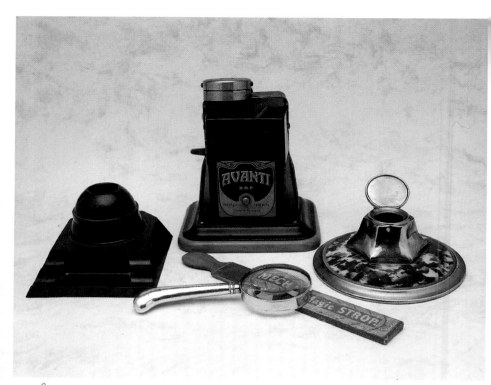

Italy, ca. 1940
Bakelite and celluloid inkwells. Avanti pencil sharpener.
Great Britain, ca. 1900: Magnifying glass and strop for pencil points.

Italia, c.a. 1940
Calamaio in bachelite; calamaio in celluloide. Temperamatite marca Avanti.
Inghilterra, c.a. 1900: Lente di ingrandimento e affilamine.

Great Britain, 1830
Silver and ivory paper knives.
Japan, 1800s: Paper knife of horn, brass, and steel.
Multibladed pocketknife of ivory and steel, 1900.
Italy, 1400s: Murano glass paperweights.

Inghilterra, 1830
Tagliacarte in argento e avorio.
Giappon, '800: Tagliacarte in corno, ottone e acciaio.
Coltello da tasca in avorio e acciaio multilame, 1900.
Italia, '400: Fermacarte Murano.

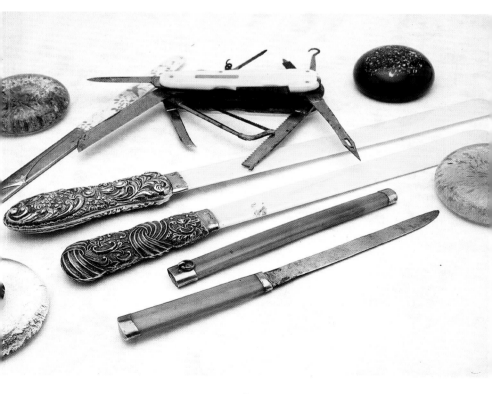

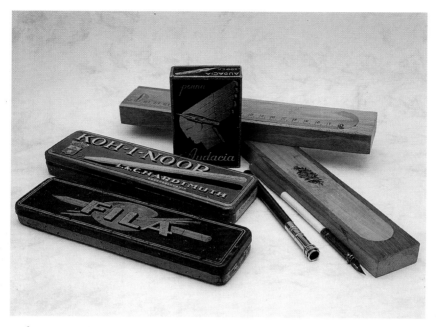

$\mathcal{I}taly$, 1930-40

Wooden pencil boxes for school.
Italy and Germany, ca. 1940: Fila and Koh-i-Noor pencil boxes.
Italy, ca. 1930: Box of Audacia nibs.

Italia, 1930-40

Astucci scolastici in legno.
Italia e Germania, c.a. 1940: Scatole portamatite marca Fila e Koh-i-Noor.
Italia, c.a. 1930: Scatola di pennini marca Audacia.

Italy and Germany, 1920-40
Ink bottles.

Italia e Germania, 1920-40
Bottiglie di inchiostro.

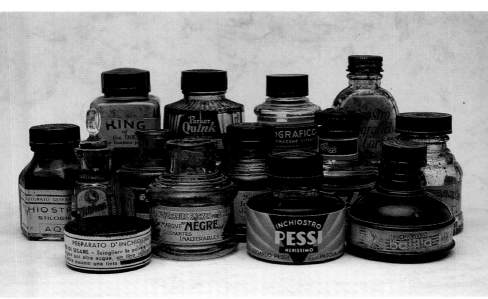

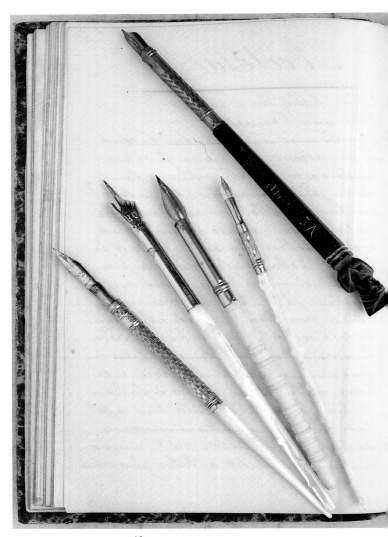

che la gomma resti attaccata al mestuoso
e quando è freddo si pone in un vaso ben turato.

Inchiostro

Prendi, noce di Galla, libbre 1.
Gomma arabica oncie 6
Vitriolo romano oncie 6
Acqua comune boccali 4
Pesta in briciole la Noce di Galla e
tienla in fusione nell'acqua, senza
bollire per lo spazio di 24 ore.
Indi aggiungevi la gomma arabica pe-
sta, e lasciala sciogliere.
Finalmente ponvi il vitriolo il quale
subito produrrà il color nero.

Inchiostro nerissimo ed eccellentissimo

Prendi, vino bianco oncie 8.
Galla oncie 6

*S*tandard pens in
mother-of-pearl,
ivory, and slate,
1850-1900.

*Penne porta pen-
nino in madreperla,
avorio e lavagna,
1850-1900.*

Fountain-pen boxes. The pens that came in four of these five boxes are shown opposite.

Stati Uniti e Inghilterra, 1900-20

Scatole di penne stilografiche. Le penne contenute in quattro di queste cinque scatole sono nella pagina a fronte.

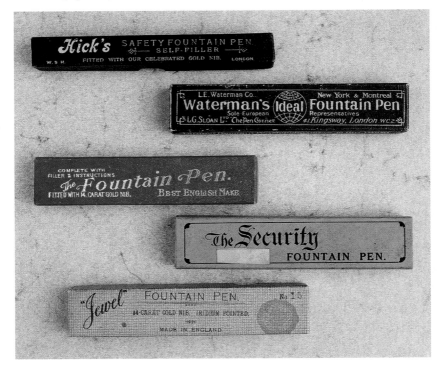

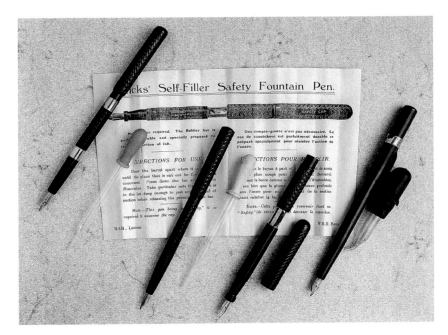

United States and Great Britain, 1900-20

Smooth-finished or chased hard-rubber pens, eyedropper filling. Each pen is accompanied by original dropper. The brands are Hick's (Great Britain), Waterman (United States), Security (Great Britain), The Fountain Pen (Great Britain). The Waterman is a model No. 12. In the background is an instruction sheet from the same period.

Stati Uniti e Inghilterra, 1900-1920

Penne in ebanite nera liscia o cesellata, con caricamento a contagocce. Ogni penna ha il suo contagocce originale d'accompagno. Le stilografiche sono della marche: Hick's (Inghilterra), Waterman (Modello "12"; Stati Uniti), Security (Inghilterra), The Fountain Pen (Inghilterra). Sul fondo foglio di istruzioni coevo.

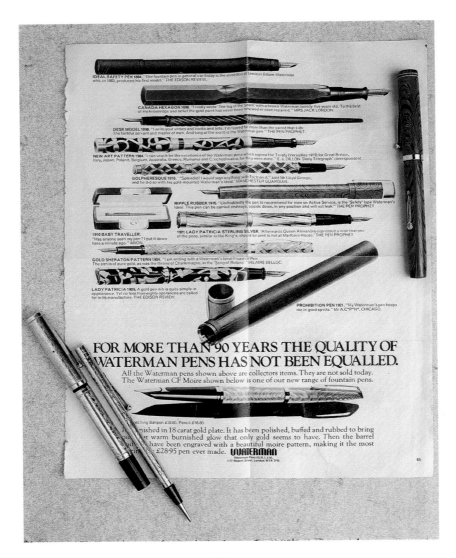

IDEAL SAFETY PEN 1884. "The fountain pen in general use today is the invention of Lewison Edson Waterman who, in 1883, produced his first model." THE EDISON REVIEW.

CANADA HEXAGON 1896. "I really wrote 'The log of the Snark' with a brown Waterman twenty five years old. To the best of my knowledge and belief the gold point has never been renewed or even repaired." MRS JACK LONDON.

DESK MODEL 1898. "I write your verses and books and bills. I'm feared far more than the sword that kills: The faithful servant and master of men, And king of the world is the Waterman pen." THE PEN PROPHET.

NEW ART PATTERN 1904. "I can vouch for the excellence of the Waterman pens which signed the Treaty (Versailles 1919) for Great Britain, Italy, Japan, Poland, Belgium, Australia, Greece, Rumania and Czechoslovakia, for they were mine." E.J. DILLON 'Daily Telegraph' correspondent.

GOLPHERESQUE 1910. "Splendid! I would sign anything with Foch on it," said Mr Lloyd George, and he did so with his gold-mounted Waterman's Ideal." MANCHESTER GUARDIAN.

RIPPLE RUBBER 1916. "Undoubtedly the pen to recommend for men on Active Service, is the 'Safety' type Waterman's Ideal. This pen can be carried endways, upside down, in any position and will not leak." THE PEN PROPHET.

1910 BABY TRAVELLER. "Has anyone seen my pen? I put it down here a minute ago." ANON.

1921 LADY PATRICIA STERLING SILVER. "Afterwards Queen Alexandra expressed a wish that one of the pens, similar to the King's, should be sent to her at Marlboro House." THE PEN PROPHET.

GOLD SHERATON PATTERN 1924. "I am writing with a Waterman's Ideal Fountain Pen. The pen is of pure gold, as was the throne of Charlemagne, in the 'Song of Roland'." HILAIRE BELLOC.

LADY PATRICIA 1929. A gold pen nib is quite simple in appearance. Yet no less than eighty operations are called for in its manufacture. THE EDISON REVIEW.

PROHIBITION PEN 1921. "My Waterman's pen keeps me in good spirits." Mr A.C*P*N*, CHICAGO.

FOR MORE THAN 90 YEARS THE QUALITY OF WATERMAN PENS HAS NOT BEEN EQUALLED.

All the Waterman pens shown above are collectors items. They are not sold today. The Waterman CF Moire shown below is one of our new range of fountain pens.

Matching Balpen £16.60. Pencil £16.60.

It is finished in 18 carat gold plate. It has been polished, buffed and rubbed to bring out that warm burnished glow that only gold seems to have. Then the barrel and cap have been engraved with a beautiful moire pattern, making it the most... £28.95 pen ever made. **WATERMAN**

Waterman Pens (U.K.) Ltd.
177 Regent Street, London W1R 7FB.

Waterman (United States), ca. 1920

left to right:

No. 0552: Gold-filled pen/pencil set in "pansy panel" pattern.

No. 7: Hard-rubber pen, in red and black "woodgrain" pattern with a purple ring on the cap. The color of the ring indicates the type of nib: purple meant a flexible fine-pointed nib. In the background is a Waterman advertisement showing models from 1915-20.

Waterman (Stati Uniti), c.a. 1920

rispettivamente da sinistra:

Modello "0552": Stilografica e portamina laminato oro a decorazione "Pansy Panel".
Modello "7": In ebanite rossa e nera "Woodgrain" con anello "purple" (violetto) sui cappuccio. Il colore dell'anello indica il tipo di pennino montato: al "purple" corrisponde un pennino flessibile a punta fine. Sullo sfondo pubblicità Waterman con modelli 1915-20.

Waterman, ca. 1920
bottom to top:
No. 0552: Hard-rubber set
with gold-filled overlay in fili-
gree style, filled using a lever
on the side. Original case.
No. 0452: Hard-rubber pen
with silver filigree-style overlay.
The No. 0552 sold for nineteen
dollars; the silver No. 0452
cost nine dollars.

Waterman, c.a. 1920
rispettivamente dal basso:
Modello "0552": Set in ebanite
e laminato oro a disegno "fili-
gree", caricamento a leva lat-
erale. Scatola a astuccio origi-
nale.
Modello "0452": In ebanite e
argento "filigree".
Il prezzo di vendita della
"0552" era di 19 dollari,
mentre la "0452" in argento
costava 9 dollari.

$\mathcal{W}_{aterman}$

top to bottom:
No. 0502, ca. 1900: Gold-
filled pen with chased design,
eyedropper filling.
No. 4 Double Twist, ca. 1890:
Pen in turned hard rubber.
No. 52, 1915: Chased hard-
rubber pen, lever filling, per-
sonalized with two gold bands
on the barrel, pressure clip.

Waterman

dall'alto rispettivamente:
Modello "0502", c.a. 1900:
Laminata oro, disegno
"chased", caricamento a con-
tagocce.
Modello "4 Double Twist",
c.a. 1890: In ebanite tornita.
Modello "52", 1915: In eban-
ite cesellata, e carica leva lat-
erale personalizzata con due
fasce d'oro sul fusto. Clip a
pressione.

*W*aterman: *Safety No. 42, 1915-30*

Three pens with retractable nibs and gold overlays. The caps are decorated with a filigree-style inlay (top), sapphires (center) and repoussé angels (bottom). The work is by Italian goldsmiths.

Waterman: "Safety 42", 1915-30

Tre penne a pennino rientrante, rivestite in laminato oro con coperchio con intarsio in filigrana (in alto), con zaffiri (al centro), sbalzato a figura di angeli (in basso). Lavori di orafi italiani. ➤

*W*aterman: *No. 0452, ca. 1920*

top to bottom:
Three hard-rubber pens, one orange and two black, with three different types of silver filigree-style overlays. Mechanical pencil.

Waterman: Modello "0452", c.a. 1920

dall'alto rispettivamente:
Tre penne in ebanite, una arancio e due nere, con tre diversi tipi di disegno "filigree" d'argento. Un portamine d'accompagno.

W*aterman: Safety No. 42, ca. 1920*

Four gold-filled pen models with a jewelry-like repoussé filigree-style overlay.

Waterman "Safety 42", c.a. 1920

Quattro modelli di penne con rivestimento in laminato oro, con lavoro di orificeria a sbalzo in filigrana.

W*aterman: Safety No. 42, ca. 1920*

Yellow and white gold–filled pen/pencil set with filigree-style design.

Waterman "Safety 42", c.a. 1920

Set di penna e portamina in laminato oro giallo e bianco a disegno in filigrana.

$\mathcal{W}_{aterman:}$ \mathcal{S}_{afety} $\mathcal{N}_{o.}$ 42. ca. 1920
Four models with gold overlays.

Waterman "Safety 42", c.a. 1920
Quattro modelli rivestiti in oro.
≺

$\mathcal{W}_{aterman}$
left to right:
No. 55, ca. 1928-30: Hard-rubber pen in "woodgrain" pattern.
No. 94, ca. 1928-30: Hard-rubber pen in "olive ripple" pattern.
No. 52½, ca. 1928-30: Hard-rubber pen in "blue-green ripple" pattern.
Lady Patrician, 1930-38: Celluloid pen/pencil set in "onyx" pattern.
No. 32, 1931-38: Gray celluloid pen with black and red streaks.

Waterman
rispettivamente da sinistra:
Modello "55", c.a. 1928-30: In ebanite "Woodgrain".
Modello "94", c.a. 1928-30: In ebanite "Olive Ripple".
Modello "52½", c.a. 1928-30: In ebanite "Blue-Green Ripple".
Modello "Lady Patrician", 1930-38: Set di penna e portamina in celluloide "Onyx".
Modello "32", 1931-38: In celluloide grigia a striature nere e rosse. ➤

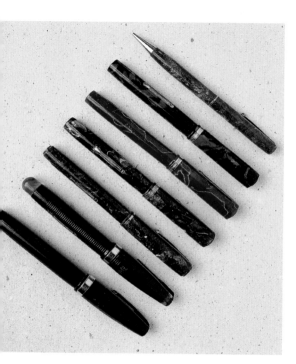

Waterman

bottom to top:

Embleme, 1947-50: Black celluloid pen.

Hundred Years, ca. 1940: Oversized "orange end"–type pen.

No. 32, ca. 1935: Green and bronze celluloid set with pen and pencil.

No. 94, 1930-39: Three celluloid pens in green and bronze, mahogany, and blue-gray.

Waterman

Dal basso rispettivamente:

"Embleme", 1947-50: In celluloide nera.

"Hundred Years", c.a. 1940: Tipo "Orange End" oversize.

Modello "32", c.a. 1935: Set in celluloide verde-bronzo.

Modello "94", 1930-39: Tre · penne in celluloide color verde-bronzo, mogano, blu-grigio.

Mabie Todd (United States/England): Swan, ca. 1900

Eyedropper-filling pen with repoussé gold-filled overlay, with original box. In the background is a 1929 advertisement for Swan pens.

Mabie Todd (Stati Uniti/Inghilterra): "Swan", c.a. 1900

Penna con caricamento a contagocce, rivestimento in laminato oro a sbalzo, scatola originale.

Sullo sfondo pubblicità delle penne "Swan", 1929. ➢

S.F. 336c, 57/6
Also S.F. 73½c, 22/6

LAPIS LAZULI
22/6

"ETERNAL"
S.F. 645 30/-

JADE
22/6

Give a
'SWAN'
PEN
and give
Pleasure

There is a pleasing range of models to suit every taste, and the "Swan" in black, mottled or colours, either singly or with a "Fyne-Poynt" Pencil, makes a charming present for either a lady or gentleman.

Self-Filling "Swans" may be obtained of all Stationers and Jewellers. Black or Mottled from 15/-; Artistic Colours from 17/6, or non-self-filling in Black from 10/6. "Fyne-Poynt" Pencils from 5/- to match "Swan" Pens.

Illustrated catalogue post free.

MABIE, TODD & CO., LTD., Swan House, 133 & 135, Oxford Street, London, W.1. Branches at: 79, High Holborn, W.C.1; 114, Cheapside, E.C.2; 95, Regent Street, W.1; and at 3, Exchange Street, Manchester.

SET No. 265a
57/6

S.F. 275c 52/6
18 ct. BAND
With Rolled
Gold Band
S.F. 219c 21/-

Presentation set comprising : Self-filling "Swan" Pen and "Fyne-Poynt" Pencil, each covered Rolled Gold, Set No. 265a 57/6. Longer length pen and pencil with clips, Set No. 765c, 68/-

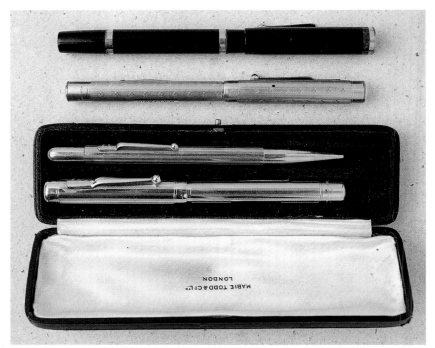

Mabie Todd: Swan, ca. 1920
bottom to top:
A gold-filled set with the original box.
Gold-filled lever-filling pen.
Black hard-rubber fountain pen with a "woodgrain"-pattern hard-rubber insert on the cap.

Mabie Todd: "Swan", c.a. 1920
Dal basso rispettivamente:
Set in laminato oro con scatola originale.
Una penna a leva laterale in laminato oro.
Una stilografica in ebanite nera con un inserto di ebanite "Woodgrain" sul cappuccio.

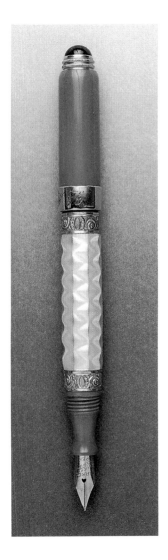

Parker (United States): No. 45, ca. 1910
Orange hard-rubber pen, with mother-of-pearl plating on the barrel and a green semiprecious stone at the tip of the cap.

Parker (Stati Uniti): Modello "45", c.a. 1910
In ebanite arancio corpo ricoperto in madreperla, una pietra dura verde sulla sommità del cappuccio.

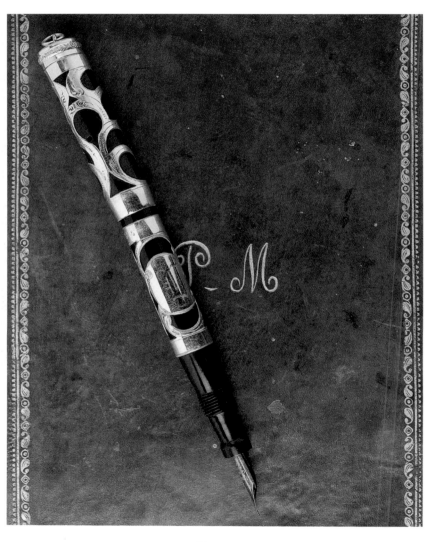

Parker: Duofold, ca. 1925
right: A lazulitic blue pen
with a chased 14-kt gold over-
lay added by an Italian gold-
smith.
left: Another Duofold with a
chased gold-filled overlay.

Parker: "Duofold", c.a. 1925

*a destra: Blu lapis, rivestita
da un orafo italiano in oro
14Kt con lavoro a cesello.
a sinistra: Altra "Duofold" in
laminato oro cesellato.* ➤

*Parker:
Jack Knife Safety No. 15, 1917-25*
Black hard-rubber pen with a gold-filled filigree-style overlay and a
button filler.

Parker: "Jack Knife Safety 15", 1917-25

In ebanite nera e laminato oro "filigree", caricamento a pulsante.
◄

*P*arker: *Duofold,* ca. 1927
Three pens made of Permanite
(celluloid) in orange, green,
and black, with matching pencil.

**Parker: "Duofold",
c.a. 1927**
*Tre penne in permanite (cellu-
loide) colori arancio, verde e
nera. Portamine d'accompagno.*

Parker: Duofold Streamline Senior, 1929-33
Three pens: in lazulitic blue (right), black and pearl, and jade green with matching
pencil (left).

Parker "Duofold Streamline Senior", 1929-33
Tre penne: di colore blu lapis (a sinistra), "Black and Pearl", verde giada con porta-mine (a destra).

\mathcal{P}_{arker}

left to right:

Vacumatic, 1937: Black pen. Vacumatic, 1939-43: Gray laminated pen/pencil set. Vacumatic, 1945: Black pen. Duofold, 1945: Green pen with vertical stripes, outfitted with the Vacumatic filling system. Vacumatic: Brown laminate with an Italian-made gold-filled overlay.

The Vacumatic system was introduced in 1933. It eliminated the rubber ink sac, making room for more ink inside. The transparent barrel of the pen let the writer check the ink level.

Parker

rispettivamente da sinistra:

"Vacumatic", 1937: Color nero. "Vacumatic", 1939-43: Set con matita, grigia ad anelli. "Vacumatic", 1945: Color nero. "Duofold", 1945: Caricamento tipo "Vacumatic" verde a righe verticali. "Vacumatic": Color marrone ad anelli rivestia in Italia in lamiato oro.

Il caricamento "Vacumatic" fu introdotto nel 1933, esso elimivata il serbatoio in lattice, consentiva l'introduzione di una maggior quantità di inchiostro e permetteva grazie al fusto della penna trasparente di controllare il livello dell'inchiostro.

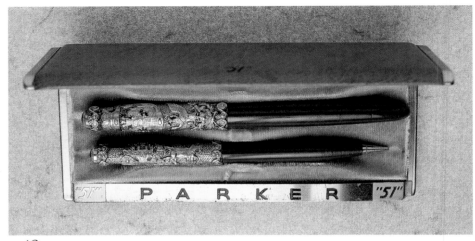

Parker: No. 51, ca. 1950

This set was not mass-produced; it was probably custom-made and is the only one of its kind. Engraved solid silver cap with gold decoration, including family crest and carriage.

Parker: Modello "51", c.a. 1950

Set non di serie, probabilmente unico ed eseguito su ordinazione. Cappuccio in argento massiccio graffiato con decorazioni d'oro, a motivo di stemma nobiliare e carrozza gentilizia.

Parker: No. 51, ca. 1945-50

top to bottom:
Two sets in black thermoformed plastic with gold-filled caps.
Set in nut brown thermoformed plastic with satin-finish steel caps.

Parker: Modello "51", 1945-50

dall'alto rispettivamente:
Due set in plastica termostampata nera e cappuccio laminato oro.
Un set in plastica termostampata color nocciola e cappuccio in acciaio satinato. ➤

36

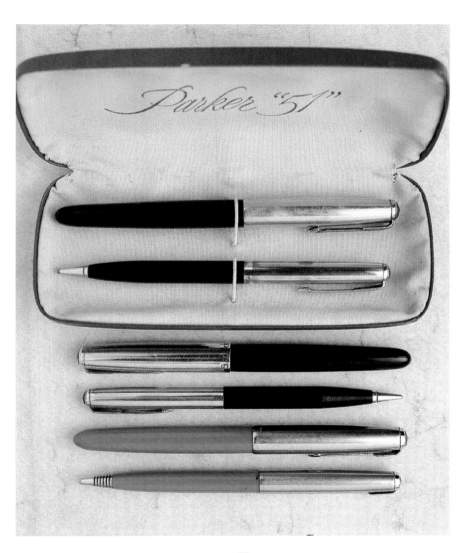

37

Probably American-made, ca. 1900
Closed collapsing pen. These pens
had extending caps. When closed,
they were much shorter and could
easily be carried in a pocket.

Produzione probabilmente americana, c.a. 1900

*Penna telescopica chiusa. Le penne
dette a telescopico avavano il capo
allungabile. Chiuse risultano molto
più corte e facilmente portabili in
tasca.*

≺

Three open collapsing pens,
eyedropper filling, ca 1900.

*Tre penne telescopiche
a contagocce aperte,
c.a. 1900.* ➤

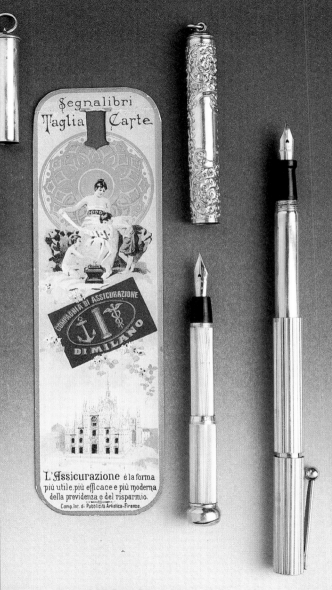

Circa 1920

left: Pencil.

right, top to bottom:
Four miniature "safety" pens
with retractable nibs:
Rouge et Noire (the original
brand name of Montblanc).
Anonymous, with a red semi-
precious stone on the tip of the cap.
Anonymous, German-made.
Anonymous, probably English.
Because it was small enough to
fit into the pockets of evening
clothes, this type of pen was
called a *frac* ("tailcoat") in Italy.

Circa 1920

A sinistra: Portamine.
A destra, rispettivamente dall'alto:
Quattro penne "Safety" in
maniatura con pennino a scom-
parsa:
Rouge et Noire (antesignana
della Montblanc).
Anonima con una pietra dura
rossa sulla sommità del cappuccio.
Anonima di produzione tedesca.
Anonima, probabilmente inglese.
Questo tipo di penne era detto
da "frac" perchè, per la loro
dimensione erano indicate per
essere portate nei taschini degli
abiti da sera.

\mathcal{S}*heaffer (United States)*

left to right: Secretary model, 1922. In red casein, with nib marked "Secretary." Such pens were made of casein before celluloid was introduced, but production was abandoned because casein pens were so vulnerable to breakage and bending.

Lifetime model, 1920-24. Made of black and pearl radite (celluloid). Lifetime models, identified by a white dot (in this case on the end of the cap), were guaranteed by the manufacturer for the entire lifetime of the owner.

Lifetime, 1920-24. In chased

black hard-rubber. The gold band on the cap indicates that it belonged a more prestigious line than the standard models.

Sheaffer (Stati Uniti)

rispettivamente d'a sinistra: Una "Secretary Red Casein" con pennino marcato "Secretary": penna prodotta in caseina prima dell'introduzione della celluloide. La produzione fu abbandonata perchè le penne prodotte in caseina erano particolarmente fragili e deformabili.

Un modello "Lifetime", 1920-22. In radite (celluloide) colore "Black and Pearl". I modelli "Lifetime", caratterizzati da un "White Dot" (punto bianco), in questo caso posto sulla sommità del cappuccio, erano garantiti dalla casa produttrice per tutta la vita del proprietario.

"Lifetime", 1920-22. In ebanite nera cesellata con una fascia d'oro sul cappuccio ad indicare una produzione di maggior prestigio rispetto al resto della produzione.

Shaeffer

center: Lifetime model, 1926.
In jade green.
left and right: No. 3.25, ca.
1925. Two pens, one in
orange celluloid, the other in
black hard rubber with verti-
cal lines.

Sheaffer

*al centro: Modello
"Lifetime", 1926. Color
verde giada.
a sinistra, a destra: Due
penne modello 3.25, c.a.
1925: Una in ebanite nera a
righe verticali, l'altra in cel-
luloide arancio.*

≺

*Shaeffer: Lifetime Balance,
1930-35*

left to right:
Black celluloid pen. Black and
pearl pen/pencil set.

Shaeffer: "Lifetime
Balance", 1930-35

*rispettivamente da sinistra:
Set in "black and pearl".
Altra penna della stessa
marca, in celluloide nera.* ≻

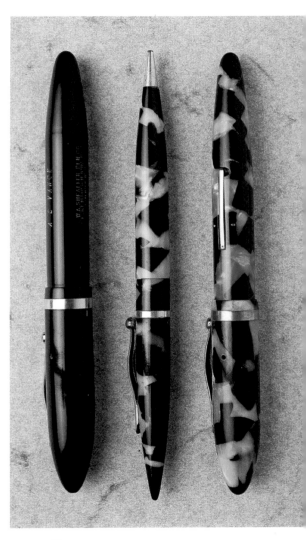

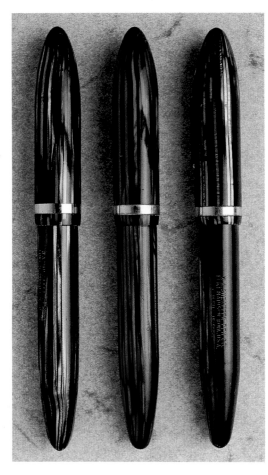

Sheaffer, 1941-46
Pen and pencil set with
military-style clip.

Sheaffer, 1941-46
*Set di penna e portamina
con clip militare.* ➤

Sheaffer: Premier Lifetime,
1932-35
Three pens: green, red, and
brown.

**Sheaffer: "Premier
Lifetime", 1932-35**
*Tre penne nei colori verde,
rosso e marrone.*
➤

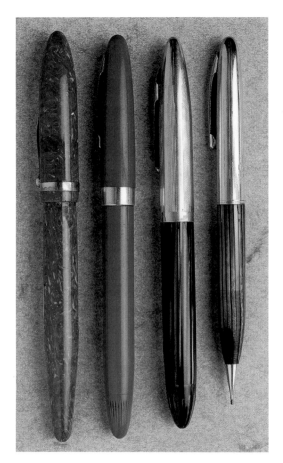

Sheaffer

left to right:
Lifetime Balance, 1933, in
emerald-green celluloid.
Saratoga, ca. 1950, in thermo-
formed blue plastic.
Crest set, 1942-45, in brown-
striped celluloid with gold-
filled cap.

Sheaffer

*rispettivamente da sinistra:
Una "Lifetime Balance" in cel-
luloide verde smeraldo del
1933.
Una "Saratoga" in plastica ter-
mostampata azzurra del 1950,
c.a.
Un set "Crest" in celluloide
marrone striata e cappuccio
placcato oro, 1942-45.*

Sheaffer: PFM ("Pen for Men") Snorkel

left to right:

Three pens: green, brown with a gold-filled cap, and black. The Snorkel, introduced in 1952, was a mechanism with a little metal tube that extended from under the nib to draw ink out of the bottle. This protected the nib from hitting the bottom of the inkwell and being damaged.

Sheaffer "PFM ('Pen for Men') Snorkel"

rispettivamente da sinistra:
Tre penne: una verde, una marrone con cappuccio laminato oro, e una nere.
Lo "Snorkel", introdotto nel 1952, è un meccanismo che determina l'uscita da sotto il pennino di un tubicino in metallo con il quale si aspira l'inchiostro dalla boccetta; questo per evitare che la punta del pennino si possa rovinare urtando il fondo della boccetta. ➤

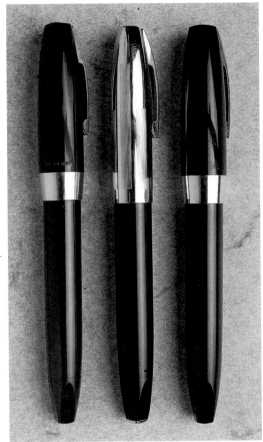

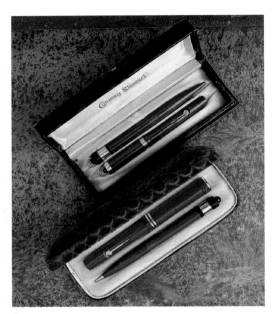

Conway Stewart
(Great Britain), ca. 1930
bottom: Dandy model, purple set.
top: Dinky model, green set.
These were pens to be carried in a handbag or in the pockets of men's evening clothes.

Conway Stewart (Inghilterra), c.a. 1930
sotto: Modello "Dandy",
Set color viola.
sopra: Modello "Dinky",
Set color verde.
Penne da borsetta o da frac.
◄

Wahl-Eversharp (United States), 1920-30
left to right:
Two gold-filled fountain pens of different sizes.
Gold-filled pencil.

Wahl-Eversharp (Stati Uniti), 1920-30
rispettivamente da sinistra:
Due penne stilografiche di diverse dimensioni in metallo laminato oro. Portamine laminato oro. ►

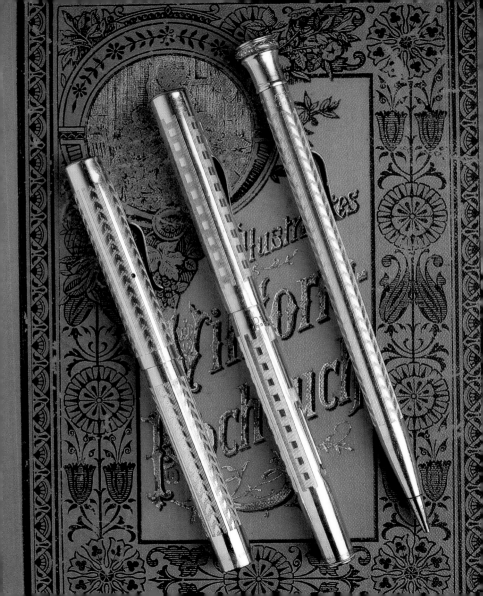

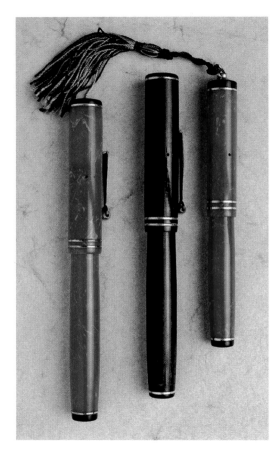

Wahl-Eversharp: Gold Seal,
ca. 1927-32
left to right:
Three examples of the
"Personal Point" type: coral-
red, chased black hard rubber,
and coral-red woman's pen.
Personal Point pens had a nib
holder that screwed into the
pen barrel. All the owner had
to do was unscrew it and
replace the nib, and the pen
was quickly converted to the
pen style of one's choice.

Wahl-Eversharp: "Gold
Seal", c.a. 1927-32
rispettivamente da sinistra:
Tre penne del tipo "Personal
Point" nei colori: rosso corallo,
ebanite nera cesellata, "Lady"
rosso corallo.
Le penne "Personal Point" ave-
vano il blocca pennino/porta
pennino avvitato al fusto della
penna. Era sufficiente perciò
svitare il blocco per cambiare
rapidamente il pennino,
secondo le personali esigenze di
scrittura del cliente.

$\mathcal{W}_{ahl\text{-}Eversharp}$

left and right: Gold Seal, 1927-32. Two Personal Point models, in emerald green and lazulitic blue. center: An oversized black and pearl Art Deco pen.

Wahl-Eversharp

a sinistra, a destra: "Gold Seal", 1927-32. Due del modello "Personal Point": una blu lapis, l'altra verde smeraldo. al centro: Una stilografica "Art Déco", oversize, colore "Black and Pearl". ➢

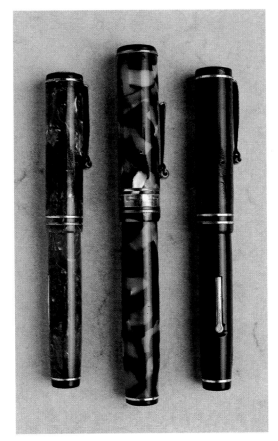

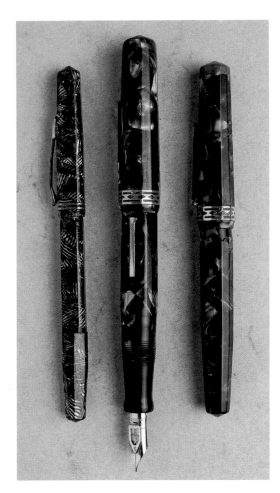

Wahl-Eversharp, 1931-41
right to left:
Doric, in burgundy.
Oversized Doric with special
adjustable nib, in Kashmir
green.
Doric Stenographic Pen, spe-
cially designed for and popular
with stenographers.
The adjustable nib was intro-
duced in 1932, and offered a
choice of from six to nine dif-
ferent stroke styles.

Wahl-Eversharp 1931-41
rispettivamente da destra:
Una "Doric" in "Burgundy"
(morocco).
Una "Doric" in verde kash-
mir—oversize, con un partico-
lare pennino regolabile.
Una "Doric Stenographic Pen",
particolarmente adatta ed
apprezzata dagli stenografi.
Il pennino regolabile, intro-
dotto nel 1932, consentiva di
ottenere dai sei ai nove tratti
diversi di scrittura.
◄

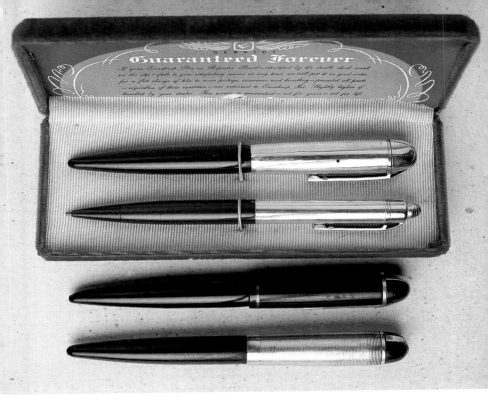

Eversharp: Skyline, 1941-49

top to bottom:

Set with celluloid body and 14-kt solid gold cap.

Blue celluloid model.

Black pen with gold-filled cap.

Eversharp: "Skyline", 1941-49

dall'alto rispettivamente:

Un set in celluloide e cappuccio di oro massiccio 14 Kt.

Un modello in celluloide blu.

Una penna nera con cappuccio laminato oro.

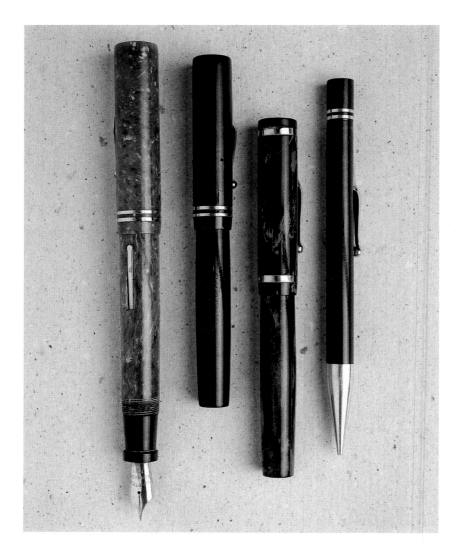

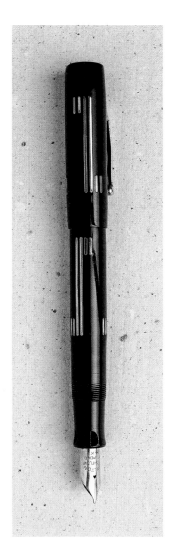

Carter (United States)

opposite page, left to right:
Oversized emerald-green pen, 1926-28.
Hard-rubber fountain pen with red and black streaks,
1926-27.
Blue marble celluloid set,
1926-28.

Carter (Stati Uniti)

rispettivamente da sinistra:
Una penna verde smeraldo oversize del 1926-28.
Una stilografica in ebanite a striature rosse e nere del
1926-1927.
Un set in celluloide blu marmorizzato, del 1926-28.

Chilton (United States): Wingflow, ca. 1920

Pump-filling pen, decorated with brass inlays on cap
and barrel.

Chilton (Stati Uniti.): "Wingflow", c.a. 1920

Penna stilografica con caricamento a pompa e deco-
razione a inserti di ottone sul cappuccio e sul fusto.

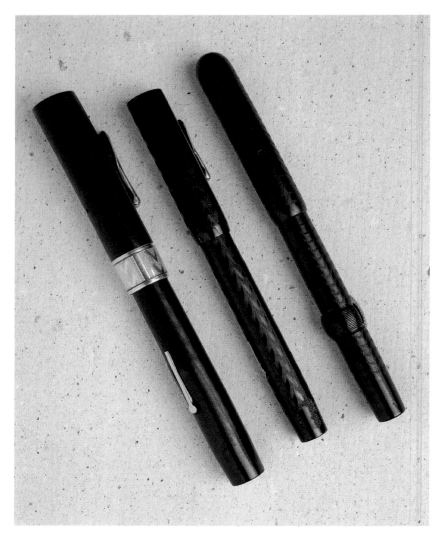

Conklin (United States)

Three chased hard-rubber pens in black, among the first to be produced by Conklin. Note the Crescent Filler, ca. 1910, with the refilling crescent protruding from the side of the barrel.

Conklin (Stati Uniti)

Tre penne in ebanite nera cesellate, tra i primi modelli della produzione Conklin. Da notare la "Crescent Filler", con la mezzaluna laterale sul fusto per la ricarica del l'inchiostro del 1910 c.a.

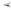

Conklin: Endura, 1927-32

left to right:
Oversized pen in lime green.
Oversized pen in blue-bronze.
Medium-sized pen in sapphire blue.

Conklin (Stati Uniti): "Endura", 1927-32

*rispettivamente da sinistra:
Una "Lime Green" oversize.
Una blu-bronze oversize.
Una sapphire-blu media.* ➤

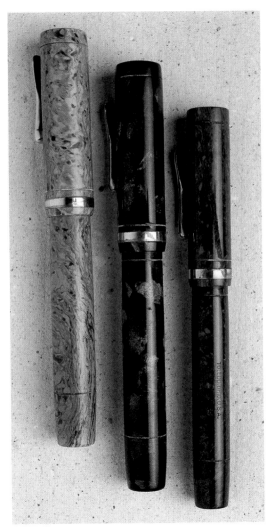

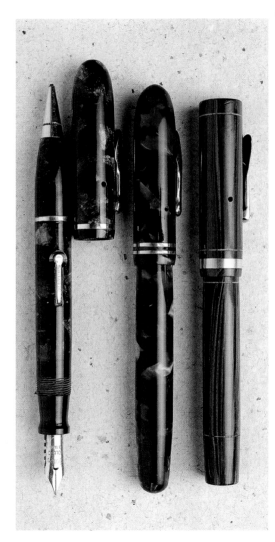

Conklin

right to left:
Endura, 1927-32: Mahogany-brown hard-rubber pen.
Ensemble, ca. 1930-32: Red and black marble-pattern pen.
Ensemble Combo, ca. 1927-32: Combination fountain pen and mechanical pencil.

Conklin

*rispettivamente da destra:
Modello "Endura", 1927-32:
In ebanite color mogano
Una "Ensemble", 1930-32:
Marmorizzata nera e rossa
Una "Ensemble Combo",
1927-32: Penna stilografica e
portamine.*

◄

United States, 1900-20

left to right:
Dunn: Camel, ca. 1920: Pump-filling pen in chased hard rubber.
Crocker: Hatchet-Filling, 1916.
John Holland: Pull-Filling, ca. 1906-10, with original box.

Stati Uniti, 1900-20

*rispettivamente da sinistra:
Dunn: "Camel", c.a. 1920: In
ebanite cesellata e caricamento a
pompa. Crocker: "Hatchet
Filling", 1916. John Holland:
"Pull Filling" 1906-10: con scat-ola originale.* ➤

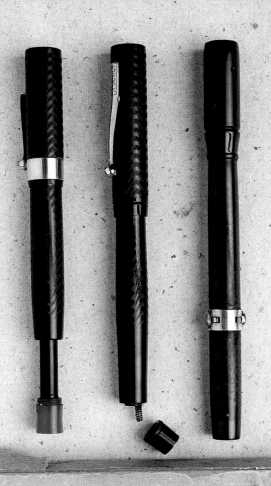

JOHN HOLLAND SELF-FILLING FOUNTAIN PEN.
PATENT NOV. 21, 05.

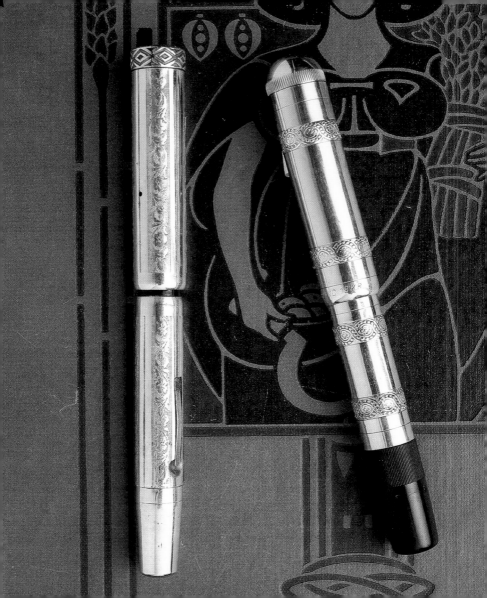

Montblanc (Germany),
ca. 1920

right: No. 4EF with retractable
nib and gold-filled overlay.
left: Lever-filling pen, likewise
with a gold-filled overlay.

**Montblanc (Germania), c.a.
1920**

*a destra: Un modello "4EF" a
pennino rientrante con rivesti-
mento in laminato oro.*
*a sinistra: Una penna a leva
laterale, sempre con rivestimen-
to laminato in oro.*

Montblanc
left to right:
Meisterstück
("Masterpiece")
No. 25, 1930, in
lazulitic blue.
No. 1 pen, ca.
1920, with retractable nib.
Hard-rubber, lever-filling pen, ca. 1920.
Rouge et Noire No. 2F from 1910—the year before Simplo changed its
name to Montblanc.

Montblanc
rispettivamente da sinistra:
Una "Meisterstück 25", 1930, in blu lapislàzzuli.
Una penna tipo "1", c.a. l920, a pennino rientrante.
Una penna in ebanite con caricamento a leva laterale sempre c.a. 1920
*Una "Rouge et Noire 2F", 1910. L'anno successivo il "Simplo" diventa
definitivamente "Montblanc".*

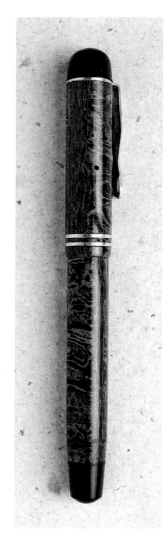

\mathcal{M}ontblanc, *1925-50*

Four orange celluloid pens made between
1925 and 1950 in Germany and Denmark.

Montblanc, 1925-50

Quattro penne in celluloide arancio,
prodotte in Germania e in Danimarca. ➢

\mathcal{M}ontblanc \mathcal{M}eisterstück, *ca. 1930*

Red hard-rubber pen with black marbling.

Montblanc "Meisterstück", c.a. 1930

Penna in ebanite rossa e marmorizzazione in nero.

‹

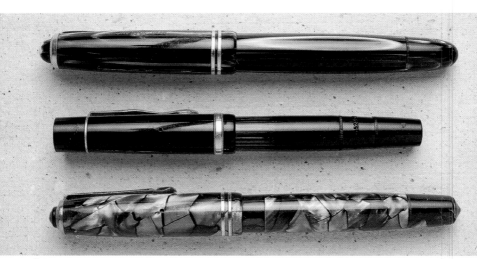

*M*ontblanc

bottom to top: No. 234 G, ca. 1935: Piston-filling celluloid pen.
No. 136: World War II–era pen produced for Montblanc in Italy, with the words "Made in Germany" inscribed in Italian on cap. No. 246, 1952: Gray celluloid pen.

Montblanc

Dal basso rispettivamente: Un modello "234 G", c.a. 1935, in celluloide con carica-mento a stantuffo. Un modello "136" della 2° Guerra Mondiale, fabbricato in Italia per conto della Montblanc, recante sul cappuccio la scritta in italiano "Fabbricata in Germania". Una "246", 1952, in celluloide grigia.

*M*ontblanc: *M*eisterstück, 1931-50

Series made in Germany, from top two price categories. In the Meisterstück series, top-of-the-line pens are marked with a larger ivory star than pens from lower price categories.

Montblanc: "Meisterstück", 1931-50

Serie prodotte in Germania tra il 1931 e il 1950, prima e seconda fascia di prezzo. Le penne di prima fascia sono caratterizzate dalle alette in avorio di maggiori dimensioni rispetto a quelle delle penne di fascia più economica.

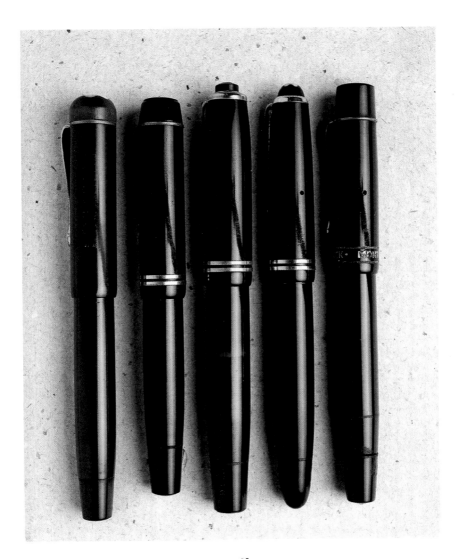

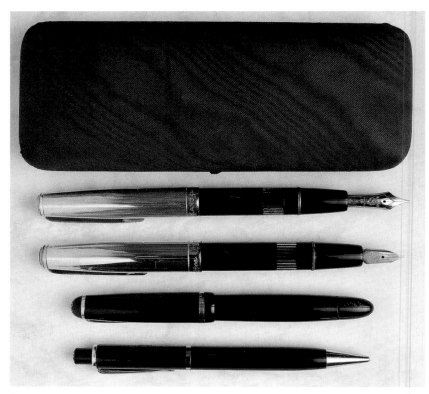

M̸ontblanc

top to bottom: No. 644 series: Two pens with gold-filled caps. One with platinum and gold nib, 1952-59, the other with Wing gold nib, 1958. No. 542 G, ca. 1959: Set of thermoformed plastic.

Montblanc

dall'alto rispettivamente: Due penne della serie "644" con cappuccio laminato oro: Una con pennino in platino e oro, 1952-59, l'altra con pennino oro "Wing", 1958. Modello "542 G", c.a. 1959: Set in plastica termostampata.

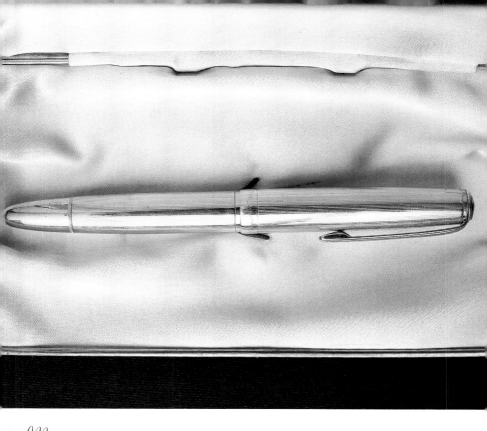

*M*ontblanc: *No. 752 N, ca. 1950*
Solid 14-kt gold. Gold-filled pens, usually of gold-plated copper, are marked "14 Kr"
(reinforced carats).

Montblanc: Modello "752 N", c.a. 1950

*In oro massiccio 14 Kt. Notare che le penne laminate oro, in genere oro su rame,
sono marcate "14 Kr" (carato rinforzato).*

Montblanc: No. 644, 1952-59
Satin-finished white metal caps and gold-filled trim.

Montblanc: Modello "644", 1952-59
Con cappuccio in metallo bianco satinato e finiture laminate oro.

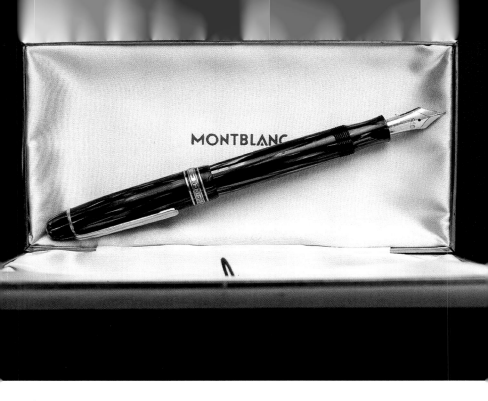

*M*ontblanc: *Meisterstück No. 144, ca. 1950*

Pen in vertically streaked green celluloid. This was the last Montblanc pen to be made of colored celluloid; in 1959, thermoformed plastic started to replace celluloid.

Montblanc: "Meisterstück 144", c.a. 1950

Serie "Meisterstück" in celluloide verde con rigatura verticale, l'ultima delle Montblanc ad essere prodotta in celluloide colorata. Nel 1959 inizia l'uso della plastica termostampata al posto della celluloide.

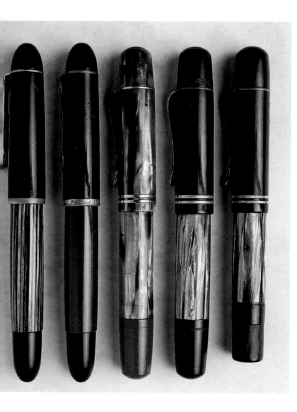

*P*elikan *(Germany)*
right to left:
No. 100, 1930: Classic black
and green pen.
No. 100, 1948: Tortoiseshell pen.
No. 100, 1948: Brick red pen.
No. 120, 1952: Pen from the
highly successful low-priced
line for students.
No. 140, 1957: Pen with
black-and-green-striped barrel
and a 14-kt gold nib.

Pelikan (Germania)
Rispettivamente da destra:
Modello "100" del 1930, nei
classici colori nero e verde.
Due modelli "100" del 1948,
nei colori tartaruga e mattone.
Modello "120" del 1952, nella
serie economica per studenti,
di grande successo
Modello "140" dell 1957 che,
rispetto alla "120", presenta
il fusto rigato verde e nero ed
il pennino oro 14 Kt.

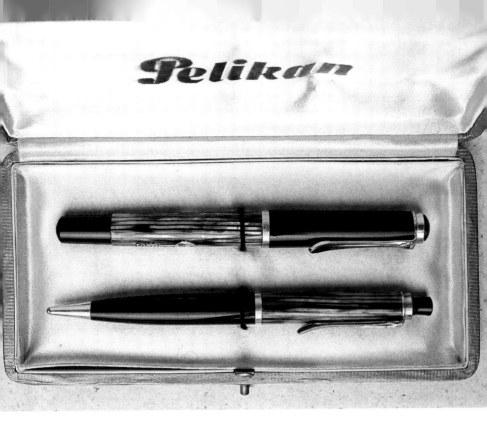

\mathcal{P}_{elikan}
top: No. 400, ca. 1950: Pen with brown cap and tortoiseshell body.
bottom: No. 450: Mechanical pencil in same style.

Pelikan
sopra: Modello "400", c.a. 1950: Cappuccio bruno con corpo tartaruga.
sotto: Portamine modello "450", negli stessi colori.

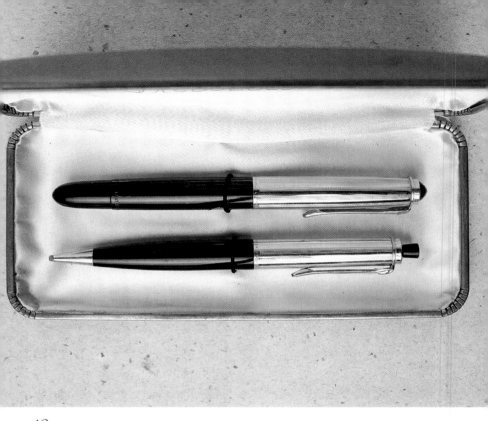

$\mathcal{P}_{elikan:}$ *No. 500 N, 1958*

The 500 line had a gold-filled cap; 1958 was the last year this pen was made with a conical barrel end.

Pelikan 500 N, 1958

La serie "500" ha il cappuccio laminato oro e nel 1958 presenta il termine del fusto conico.

\mathcal{D}unhill-Namiki (Japan), 1930

Woman's model, red lacquer with powdered-gold design of carp and flowers.
In 1925 Namiki began making fountain pens with lacquer exteriors using the traditional *maki-e* process. It was soon imitated by the other Japanese makers, particularly Sailor and Platinum. These pens were immensely popular worldwide. In 1930, Dunhill signed an agreement to market Namiki pens with a Dunhill nib in England, under the name Dunhill-Namiki.

Dunhill-Namiki (Giappone), 1930

La penna è un modello "Lady" in lacca rossa e disegno di carpe e fiori in polvere oro. Nel 1925 la Namiki iniziò la produzione di penne stilografiche rivestite in lacca, secondo il tradizionale procedimento Maky-E., imitata presto dalle altre case giapponesi, in particolar modo la Sailor e la Platinum. Queste penne ebbero un enorme successo in tutto il mondo. La Dunhill nel 1930 si assicurò la commercializzazione in Inghilterra delle Namiki con pennino Dunhill e la denominazione "Dunhill-Namiki".

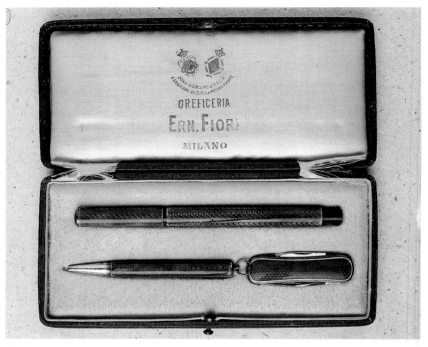

Italy, 1910
Set with fountain pen, mechanical pencil, and penknife; silver with blue enameling.
The box bears the inscription "Gift from His Majesty the King of Italy—Goldsmith
Ern. Fiore, Milan."

Italia, 1910
*Set di penne stilografiche, portamine e temperino in argento e smalto azzurro. La
scatolae porta la scritta "Dono di S. M. il Re d'Italia—Oreficeria Ern. Fiore,
Milano".*

Aurora (Italy), ca. 1920
Two gold-filled retractable-nib models.

Aurora (Italia), c.a. 1920
Due modelli a pennino rientrante laminato oro.

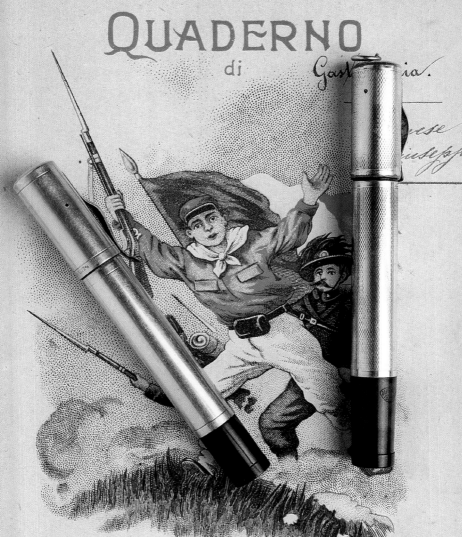

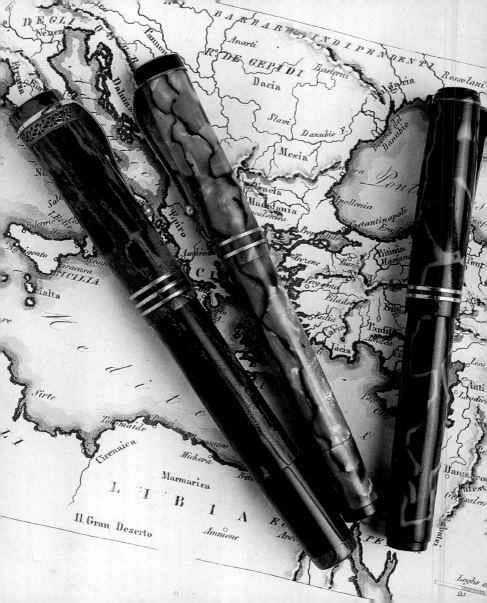

Aurora (Italy), 1925-30
left to right:
The Internazionale, in red and black hard rubber. The Internazionale was one of Aurora's top models, and one of the most attractive pens produced in Italy. It was also available in lazulitic blue, red, green, orange, and gold filled.
Duplex, in marbled pattern. Another marbled celluloid pen, lever filling, early 1930s.

Aurora (Italia), 1925-30
rispettivamente da sinistra: Modello "L'Internazionale" in ebanite rossa e nera. "L'Internazionale" è stata uno dei modelli di punta dell'Aurora e una delle penne più belle prodotte in Italia. E'disponibile anche nei colori: blu lapis, rosso, verde, arancio e laminato oro. "Duplex", marmorizzato. Penna in celluloide marmorizzata, carica a leva laterale, inizio anni '30.

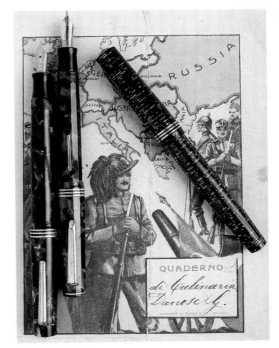

Aurora: Novum, 1930
Available in both faceted and round versions, this pen had a unique filling system. To fill the barrel with ink, you simply pulled a little lever at the barrel end. There was no need to remove the cap.

Aurora: "Novum", 1930
Disponibile nelle versioni sfaccettate e tonda, aveva un originale sistema di caricamento. Una piccola leva posta sul fondo della penna: era sufficiente muoverla per riempire di inchiostro il serbatoio, senza dover svitare il tappo di fondo.

Aurora: Novum
Models of various sizes and colors.

Aurora: "Novum"
Modelli di diverse dimensioni e colori.

Aurora: Novum

Four Novum pens. Note that one still has its price tag.

Aurora: "Novum"

Quattro "Novum". Da notare una reca ancora la targhetta del prezzo di vendita.

*A*urora: *Novum*

Group of round pens. After 1936, the year when the League of Nations imposed economic sanctions against Italy for its invasion of Ethiopia, Aurora eliminated its gold nibs and introduced nibs made of "platiridium."

Aurora: "Novum"

Serie di "Novum" rotonde. Dopo il 1936, anno delle sanzioni economiche da parte delle Nazioni Unite contro l'Italia, a causa dell'invasione dell'Etiopia, l'Aurora eliminò il pennino d'oro e introdusse quello in "Platiridio".

Aurora: Superba, ca. 1930
Pen and pencil set in flashy coral red.
Notebook designed by Rubino.

Aurora: "Superba", c.a. 1930
Set di penna e portamine in uno sgargiante rosso corallo.
Quaderno disegnato da Rubino.

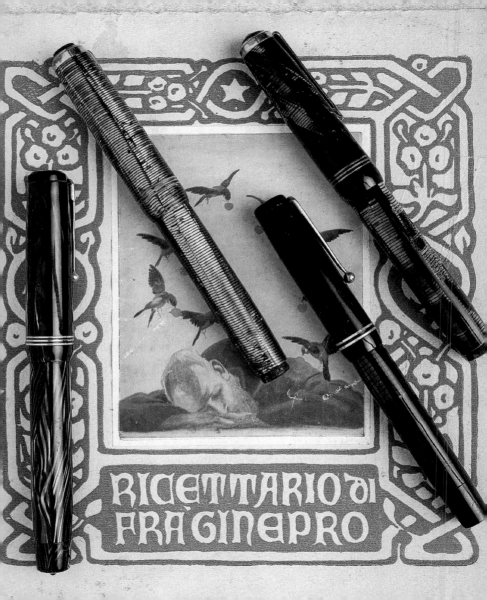

Aurora, ca. 1940
bottom: Two Selene models with white metal trim.
top: Two Novum models in laminated celluloid.

Aurora, c.a.1940
sopra: Due penne tipo "Selene", con finiture in metallo bianco.
sotto: Due modelli "Novum" in celluloide anellata.

≺

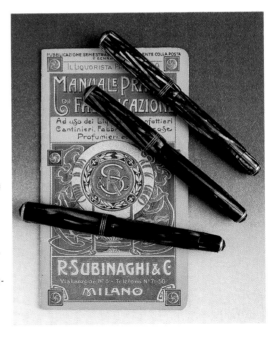

Aurora: Optima, late 1940s
Group of three button-filling
pens, celluloid with marbled
and streaked patterns.

**Aurora: "Optima", secon-
da metà '40**
*Serie di tre "Optima" in cellu-
loide marmorizzata e rigata
con caricamento a pulsante o
a depressione.* ≻

Italy, 1920-30

Gold-filled pens with retractable nibs, plus pencils.
Three sets, by Araldica (left), Ma-Gus (center), and
Zenith Extra (right).

Italia, 1920-30

*Serie di penne a pennino rientrante e portamine lami-
nati oro. Tre set di penne e portamine delle marche:
Araldica (a sinistra), Ma-Gus (al centro) e Zenith Extra
(a destra).* ➣

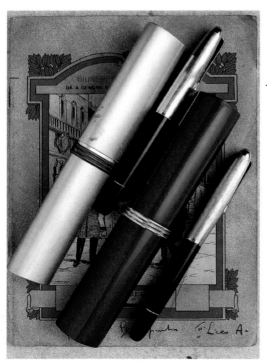

Aurora: No. 88, 1947

This pen by the designer Marcello
Nizzoli was immensely successful.
It came in two varieties, with a
cap that was either gold filled or
made of a white metal dubbed
"Nikargenta". Both had a hooded,
or protected, nib modeled after
the nib of the Parker No. 51.

Aurora: Modello "88", 1947

*Disegnata dal designer Marcello
Nizzoli fu una penna di enorme
successo. Fu prodotta in due vari-
anti, con cappuccio laminato oro o
in metallo bianco chiamato
"Nikargenta", ma sempre con il
pennino corazzato, sulla scia di
quello della Parker Modello "51".*
➣

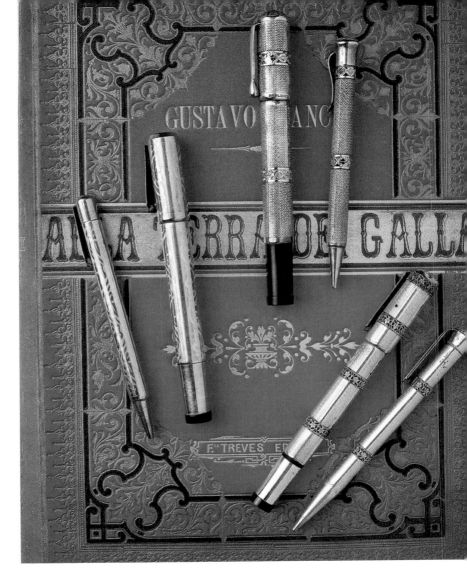

*I*nvicta *(I*taly), *ca.* 1930

left: Pen with retractable nib, two white gold–filled bands with Greek key decoration.
right: Anonymous, lever-filling pen with checkered black enamel cap. The two models
are laid against majolica oil lamps from southern Italy, of the popular type called *lumericchi.*

Invicta (Italia), c.a. 1930

Penna a pennino rientrante con due fasce in oro bianco laminato con decorazione a greca.

Penna anonima a leva laterale con decoro di quadratini di smalto nero sul cappuccio.

I due modelli sono poggiati su maioliche popolari del sud Italia, con funzione di lumi ad olio detti "lumericchi".

Columbus (Italy), ca. 1920-30

Group of gold-filled button-filling pens with retractable nibs and a variety of chased designs. They are leaning against Indian ointment pots from the late nineteenth century.

Columbus (Italia), c.a. 1920-30

Sono qui presentate una serie di penne laminate oro, a pennino rientrante e a caricamento a pulsante, con diversi decori a cesello. Poggiate su porta unguenti indiani fine secolo 1800.

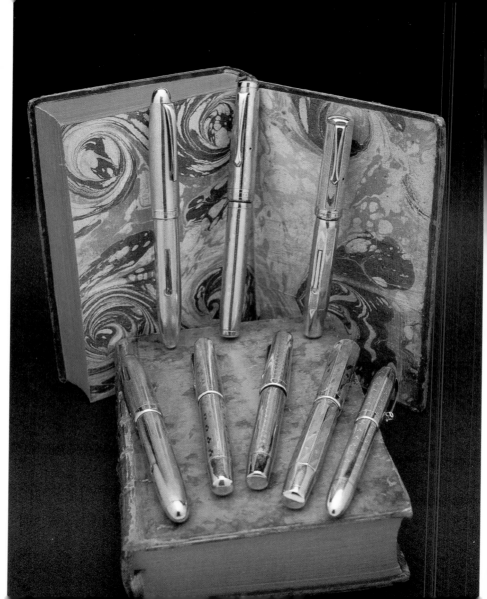

\mathcal{C}*olumbus, 1930-40*
A group of gold-filled
models.

Columbus, 1930-40
Serie di laminate oro.

\mathcal{C}*olumbus*
Several junior pens, with round and faceted designs.

Columbus
Modelli diversi di "Junior", tonde e sfaccettate.

Italy, 1920-30
Gold-filled pens. The repoussé
caps are particularly noteworthy.
Made by Fendograph, Electa,
Vega Fountain Pen, and Eterna.

Italia, 1920-30
*Penne laminate. I cappucci a
sbalzo sono di particolare rilievo.
Modelli delle marche:
Fendograph, Electa, Vega
Fountain Pen e Eterna.*

ROMA – TEMPIO DI VESTA

QUADERNO

Italy, 1920-30

Gold-filled pens, with retractable nibs.
This type of pen was very widely used in
Italy. Along with the better-known manu-
facturers of fountain pens were many
small companies that specialized in this
type alone, or just made metal overlays
for black hard-rubber pens manufactured
elsewhere. These pens were also sold in
jewelry stores, and were considered pres-
tigious gifts for many occasions. The
brands shown here are Aquila, Ideal, and
Falcon Pen.

Italia, 1920-30

*Ancora penne a pennino rientrante, lami-
nate oro. Questo tipo di penna ebbe una
grande diffusione in Italia e, accanto a
marche note di stilografiche, si incontra-
no numerose marche minori, specializzate
nella produzione di questo tipo di penne,
o anche solo nel rivestimento in metallo
di penne in ebanite nera prodotte da altri.
Esse venivano commercializzate anche nei
negozi di orafi ed erano considerate
oggetto di regalo importante per molte
occasioni. Sono qui presentati modelli
delle marche: Aquila, Ideal e Falcon Pen.*

Electa and Eterna (Italy),
1920-30
Gold-filled pens with note-
worthy repoussé caps.

**Electa e Eterna (Italia),
1920-30**
*Penne laminate; da notare i
cappucci a sbalzo.*

◄

Omas (Italy): Extra, 1932
Group of Extra models from
Omas (Officine Meccaniche
Armando Simoni). Founder
Armando Simoni began his
career by producing spare parts
for imported pens. The Extra was his first big success. Made in two versions, round and
faceted, they came in several sizes and ten colors. In the background, an advertising
leaflet for the Omas Lucens, 1936.

Omas (Italia): "Extra", 1932
*Serie di penne denominate "Extra" della Omas (Officine Meccaniche Armando Simoni).
Armando Simoni iniziò la sua carriera producendo pezzi di ricambio per penne di impor-
tazione. La "Extra" fu il suo primo grande successo. Prodotta in due versioni, tonda e
sfaccettata, ebbe varie misure e 10 colori. Sul fondo foglio pubblicitario della Omas
"Lucens" (1936).*

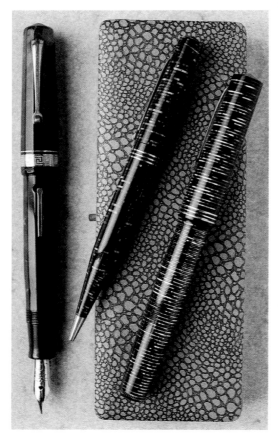

$O_{mas:}$ *Extra*

The Extras from the first
series, in 1932, have a gold
band on the cap with a
Greek key decoration. In the
second series, the cap has
three rings.

Omas: "Extra"

*Le "Extra" della prima
serie, del 1932, hanno una
fascia dorata sul cappuccio,
con decoro a greca. Nella
seconda serie il cappuccio
presenta tre anelli.*

≺

$O_{mas:}$ *Extra*

Models from the first series,
in different colors.

Omas: Extra

*Penne della prima serie con
colorazioni diverse.* ➤

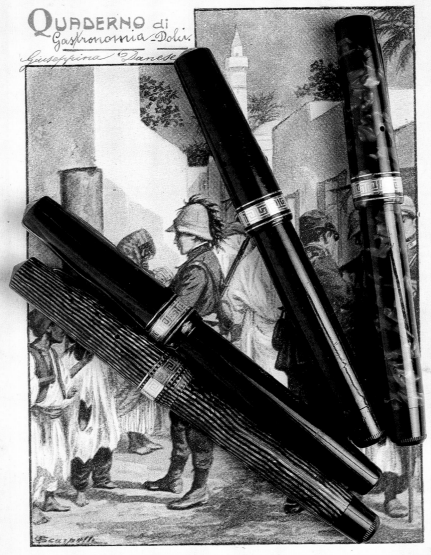

LA GENEROSITÀ DEI NOSTRI SOLDATI.

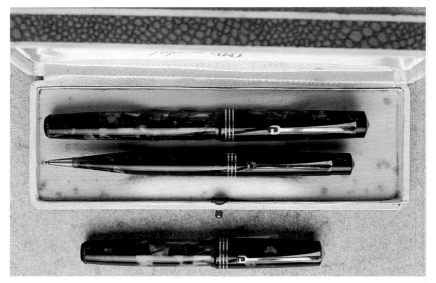

O*mas: Extra Lucens, 1936*

Junior pen and pen and pencil set with original case. Unlike the original Extra, this model had a transparent barrel, hence the name Lucens ("light-filled"). This feature let the writer check how much ink was left in the pen, and the plunger-filling system eliminated the need for a rubber ink sac. This pen still has the clip with a little roller that was typical of the Extra.

Omas: "Extra Lucens", 1936

Sono qui fotografate una penna junior e un set di penna e portamine, a fusto cilin-drico, con astuccio originale. Rispetto alla "Extra" presenta il fusto trasparente, da cui deriva il nome "Lucens", che consente di controllare la quantità di inchiostro che rimane nella penna ed il sistema di caricamento a stantuffo tuffante, che elimina il serbatoio in lattice. Essa ha ancora la clip con la rotella, tipica della "Extra".

*O*mas: *Lucens, ca. 1938*
Senior pen and pocket pen, both faceted with new arrow-shaped clip design.

Omas: "Lucens", c.a. 1938

Penna senior e penna da taschino tipo "Lucens" sfaccettate. Hanno il nuovo clip a forma di freccia.

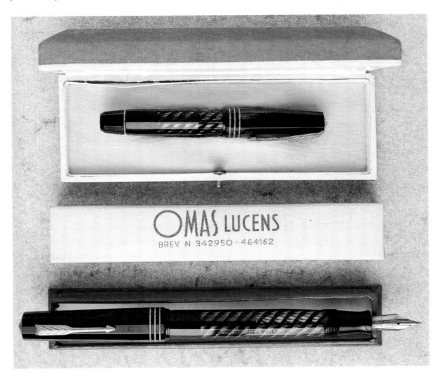

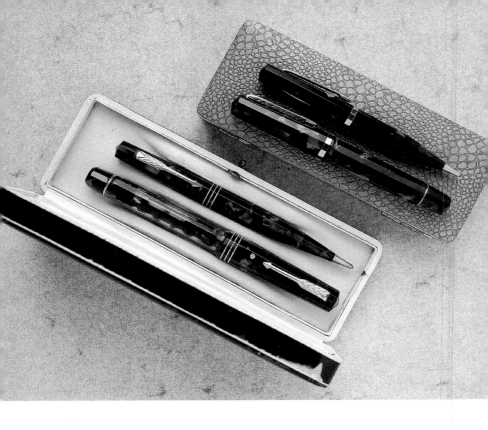

$O_{mas:}$ *Lucens, ca. 1938*
Two pen and pencil sets, tortoiseshell celluloid, with faceted barrels and caps.

Omas: "Lucens", c.a. 1938
Due set di penne e portamine in celluloide tartarugato con fusto e cappuccio sfaccettato.

$O_{mas:}$ $Extra$

Two postwar-era pens.
In this period, the lever-filling
system was discontinued,
replaced by the plunger-filling
system. Both pens have a small
transparent window through
which the writer could check the
ink level.

Omas: "Extra"

*Due penne del dopoguerra. È
stato eliminato il sistema di cari-
camento a leva ed adottato
quello a stantuffo. Entrambi le
penne hanno una finestrella
trasparente per controllare il liv-
ello dell'inchiostro.* ➢

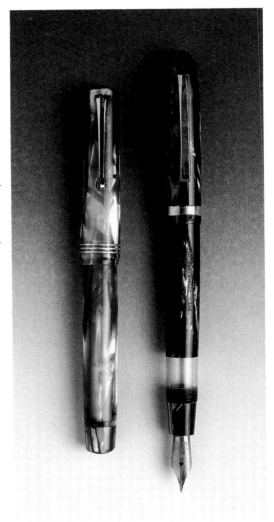

*O*mas: *361 series, 1948*

top: No. 361 C with gold-filled cap. bottom: No. 361 F, in gray marbled celluloid.
The No. 361 was typical of a number of pens that appeared immediately after World
War II. It had a distinctly ogival shape, a gold-filled cap on a monochrome barrel, and
a hooded nib. The difference was in the nib: it allowed you to write with either face.

Omas: Serie "361", 1948

sopra: Una "361 C" con cappuccio laminato oro. sotto: Penna della serie "361 F" in cel-
luloide marmorizzata grigia.

La "361 " rientra nella tipologia di penne comparse nell'immediato dopoguerra. Adotta
una forma marcatamente ogivale, il cappuccio laminato oro su fusto monocolore, e il pen-
nino corazzato. Proprio il pennino la differenzia dalle altre penne. Esso ha la caratteris-
tica di poter scrivere da entrambe le facce.

O*mas: Extra, 1950*
Three faceted pens in
black and gray marbled
celluloid.

Omas: "Extra", 1950
Tre penne del tipo sfac-
cettato in celluloide nera
e grigia marmorizzata. ➤

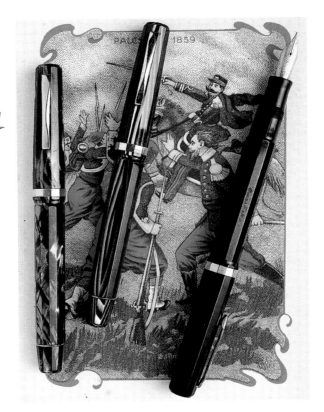

Omas: *Colorado, 1945*

The Colorado had a double barrel with a double nib, allowing the use of two different colors of ink. The pen opens like scissors, effectively becoming two pens.

Omas: "Colorado", 1945

La "Colorado" ha doppio serbatoio e doppio pennino, per utilizzare due inchiostri di colore diverso. L'apertura a forbice permette di disporre di due penne.

\mathcal{M}ontegrappa (Italy), mid-1930s

Group of pens and pencils.

This company, founded by Alessandro Marzotto in 1921 in Bassano del Grappa, produced large numbers of good-quality pens with gold nibs. It was affiliated with Elmo, which specialized in more economical steel-nibbed pens designed for students.

Montegrappa (Italia), metà '30

Serie di penne e portamine.

Questa casa, fondata nel 1921 a Bassano del Grappa da Alessandro Marzotto, ebbe una vasta produzione di penne di buon livello con pennino oro. Era consociata con la Elmo, specializzata in penne più economiche, destinate agli studenti, con pennino in acciaio.

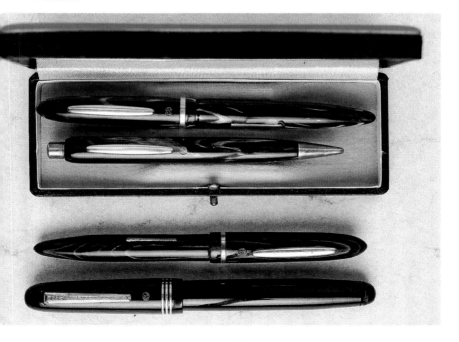

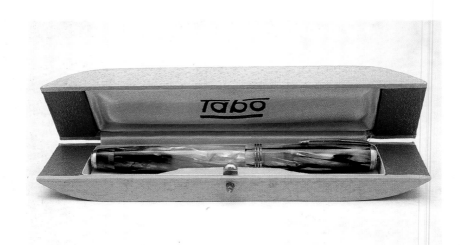

\mathcal{T}_{abo} *(Italy)*

In 1927, the company's founder, Tantini, began producing fountain pens in Bologna, hence the company's name—a grafting of the words Tantini and Bologna. Tabo's best pens were produced between 1930 and 1940, of marbled or laminated transparent celluloid, with the Vacumatic filling system.

Tabo (Italia)

Il fondatore, Tantini, iniziò a produrre penne stilografiche nel 1927 a Bologna. Da qui la denominazione Tabo (Tantini-Bologna). Le migliori penne furono prodotte tra il 1930 e il 1940, in celluloide trasparente marmorizzata o anellata, con il sistema di caricamento "Vacumatic".

$\mathcal{T}_{abo,}$ *1930-40*

Three pens in different colors, with original cases.

Tabo, 1930-40

Tre modelli con astuccio originale di diverso colore. ➤

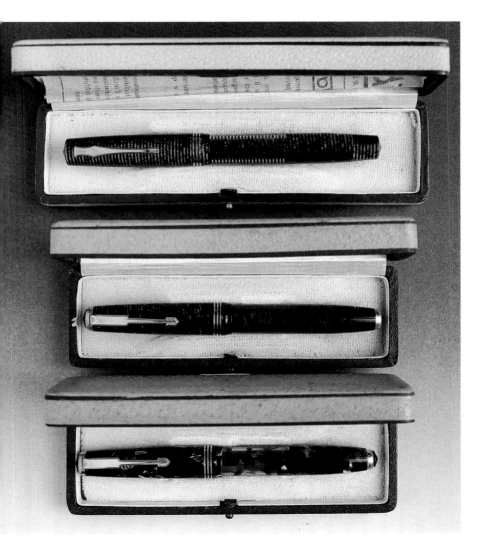

*T*abo, *1930-40*

top and bottom: Two sets made of clear laminated celluloid, with original cases.
center: Single pen, red laminated celluloid.

Tabo, 1930-40

sopra e sotto: Due set in celluloide trasparente anellata con astuccio originale.
al centro: Penna in celluloide anellata color rosso.

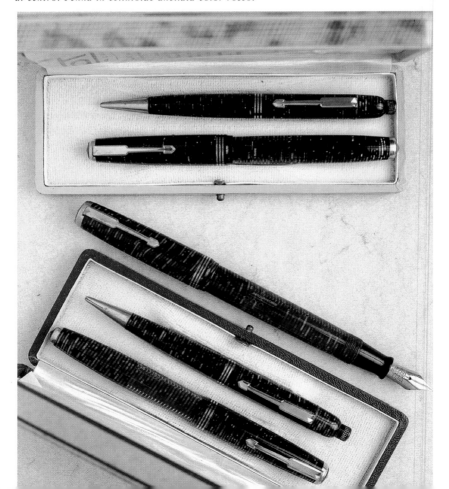

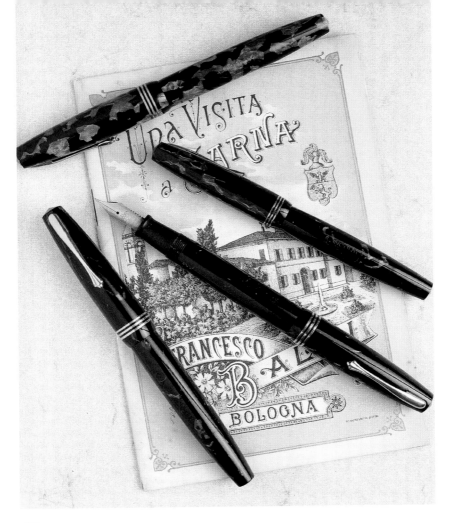

Tabo, 1940s
Four fountain pens in different colors.

Tabo, anni '40
Quattro stilografiche di diverso colore.

109

Tabo, 1930-40

Two pens with original
metal cases.
In the background is
their illustrated
brochure.

Tabo, 1930-40
*Due penne con astucci
metallici originali.
Sullo sfondo il proprio
depliant illustrativo.*

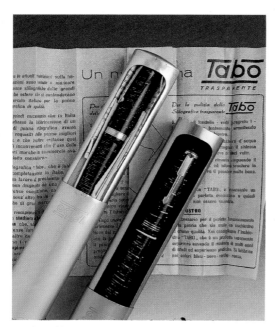

Tibaldi (Italy), 1920-50

A variety of button-filling models,
one with a sphere-tipped clip in
the style of the Parker Duofold,
dating from the 1920s to the
1950s. Founded in Florence in
1916, Tibaldi was outstanding for
its high-quality pens. The most
important line was Impero, from the mid-1930s. Made of green
laminated celluloid in medium size and tortoiseshell celluloid in
large size, these used the Vacumatic filling system and were out-
standing for their elegant shape and top-quality materials.

Tibaldi (Italia), 1920-50
*Nata a Firenze nel 1916, la Tibaldi si è contraddistinta per una
produzione di penne di elevato standard. Qui è riprodotta una
serie di penne: dagli anni '20, con carica a pulsante e clip termi-
nante con una sfera, tipo Parker "Duofold", agli anni '50. Ma
indubbiamente la serie più importante è quella denominata
"Impero", metà anni '30. In celluloide verde anellata nella misura
media e in celluloide tartarugata nella misura grande, esse adot-
tano il caricamento tipo "Vacumatic" e si distinguono per la raffi-
natezza delle forme e gli ottimi materiali usati .* ➤

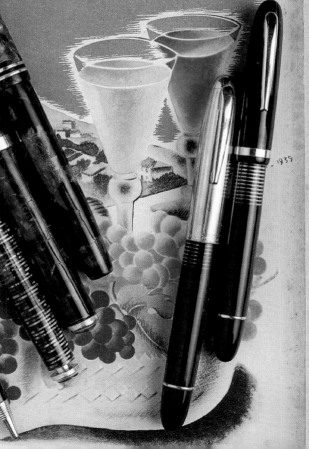

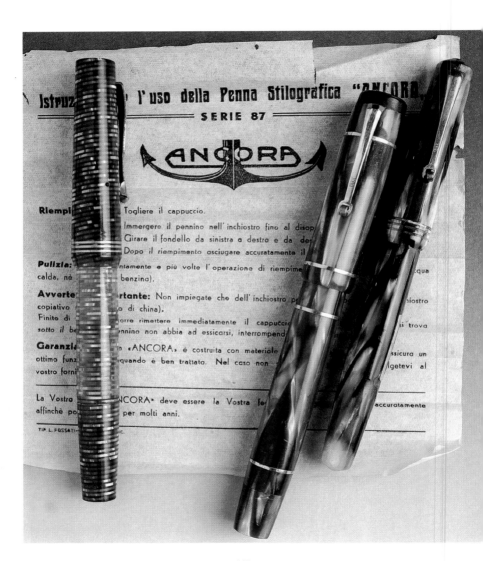

Istruz... ... l'uso della Penna Stilografica "ANCORA"

=== SERIE 87 ===

ANCORA

Riempi... Togliere il cappuccio.

Immergere il pennino nell'inchiostro fino al disop...
Girare il fondello da sinistra a destra e da de...
Dopo il riempimento asciugare accuratamente il...

Pulizia: ...ntamente e più volte l'operazione di riempime... ...qua
calda, nè ... benzina).

Avverte... ...rtante: Non impiegate che dell'inchiostro p... ...iostro
copiativo ...o di china).
Finito di ...orre rimettere immediatamente il cappucci... ...si trova
sotto il be... ...ennino non abbia ad essicarsi, interrompend...

Garanzia... ...a «ANCORA» è costruita con materiale... ...ssicura un
ottima funz... ...quando è ben trattata. Nel caso non... ...lgetevi al
vostro forni...

La VostraNCORA» deve essere la Vostra fe... ...accuratamente
affinchè po... ... per molti anni.

TIP. L. FOSSATI-... ...IC.

112

Ancora, mid-1930s

Three celluloid pens, most
notably a large Duplex of tor-
toiseshell celluloid. The first
Ancora models were made of
hard rubber with a retractable
nib; then the company went on
to make faceted celluloid models
and the 70 series equipped with
a Sheaffer-type reversed
syringe–filling mechanism.

Ancora, metà '30

*I primi modelli Ancora sono in
ebanite con pennino rientrante,
si passa successivamente ai
modelli in celluloide sfaccettati
contrassegnati ed alle serie
"Settanta" dotata di un riempi-
mento a siringa rovesciata tipo
Sheaffer. Qui sono riprodotte
tre penne in celluloide della*

*metà degli anni '30, tra cui spicca una "Duplex" di grande formato, in celluloide tar-
tarugata.*

Ancora (Italy):
Calamus, 1940s

This line of pens is identifiable by the anchor engraved on the clip and the
unique classic shape. Laminated or marbled celluloid.

Ancora (Italia):
"Calamus", anni '40

*Penne stilografiche caratterizzate dall'ancora incisa sulla clip e dalla clas-
sica forma originale. In celluloide marmorizzata o anellata.*

◄

113

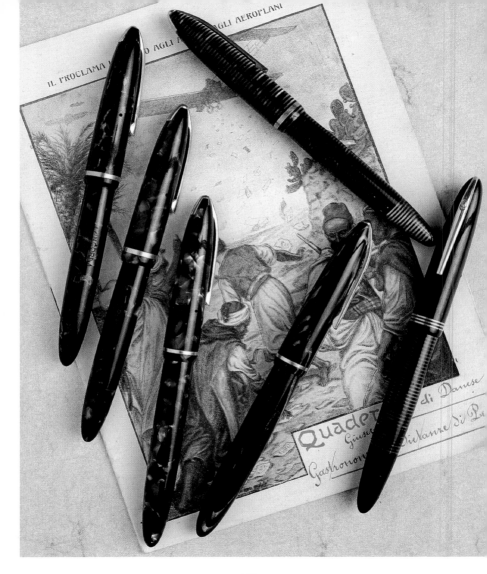

Ancora, 1940s
More fountain pens from this manufacturer.

Ancora, anni '40
Altre penne stilografiche della stessa marca.

≺

Ancora, 1940s
Another group of Ancora pens.

Ancora, anni '40
Ancora una serie di penne della produzione Ancora.

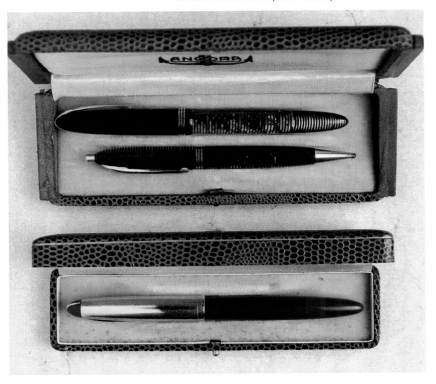

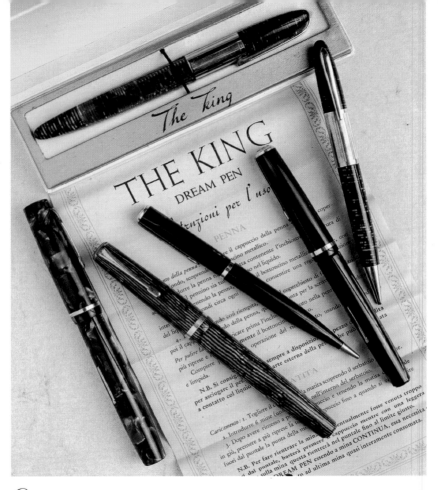

*O*_{mas}, 1930-40

These pens were marketed under the names Minerva and The King.

Omas, 1930-40

Queste penne erano prodotte dalla Omas e commercializzate con i nomi Minerva e The King.

Columbus, early 1920s

Coral-red celluloid fountain pen. This pen is very similar to the Parker Duofold Big Red, which it imitates in color, shape, and detailing.

Columbus, prima '20

Penna stilografica in celluloide rosso corallo. E'molto simile alla Parker "Duofold Big Red", di cui imita il colore, la forma e i dettagli.

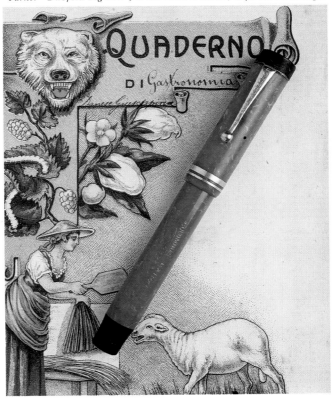

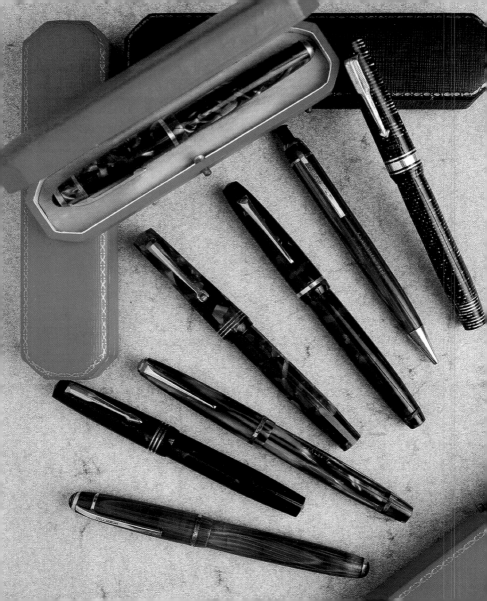

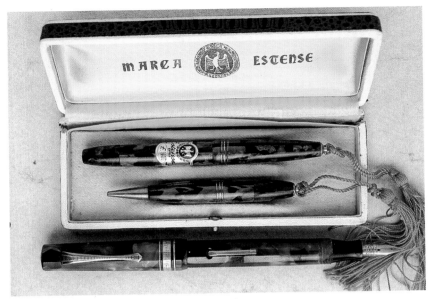

Austura (Italy)

Faceted marble celluloid pen typical of Italian models of the 1930s. Estense (Italy): Woman's set from this Ferrara-based maker, which produced a considerable number of economical and mid-range pens between the 1920s and the 1940s.

Austura (Italia):

Penna in celluloide marmorizzata e sfaccettata, tipica produzione italiana anni '30. Estense (Italia): Set "Lady" della casa di Ferrara, che ebbe una buona produzione negli anni '20-'40 di penne economiche e di medio livello.

Columbus, 1930-40

In the thirties, Columbus stopped trying to imitate American pens and developed its own characteristic design instead. The main product line was the 130 series, and had a unique clip design and two rings on the cap.

Columbus, 1930-40

Serie di penne prodotte tra il 1930 e il 1940. La Columbus ha abbandonato l'imitazione delle penne americane ed ha sviluppato un proprio design caratteristico. La linea principale è quella delle penne denominate con il numero "130", che presentano l'originale clip con due anelli sul cappuccio.

119

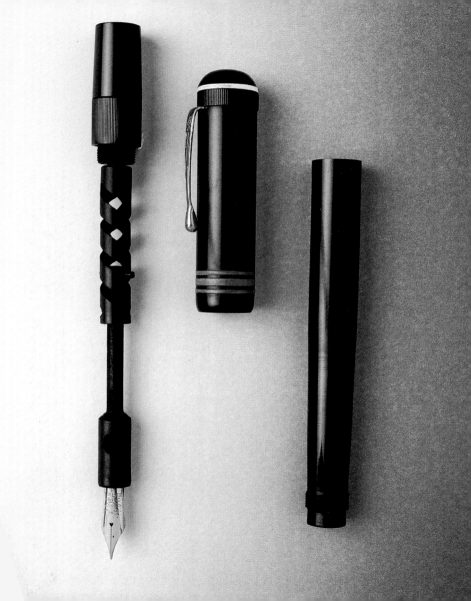

*R*etractable-nib fountain pen. Note the internal spiral mechanism.

Penna stilografica a pennino rientrante. Si vede il meccanismo interno a spirale.

≺

*B*utton-filling fountain pen, showing internal parts and nib.

Penna stilografica con carica mento a pulsante: vengono mostrate le parti interne ed il pennino.

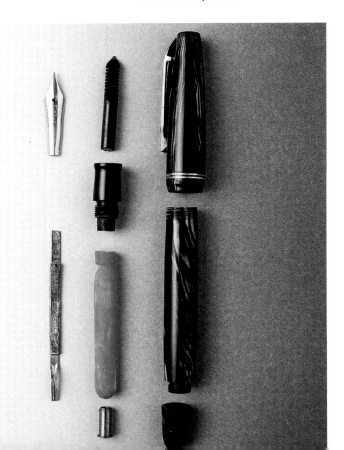

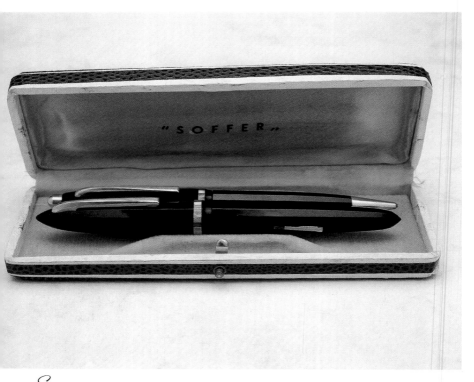

Soffer (Italy), ca. 1940

Soffer pens were produced at Settimo Torinese, near Turin, a town with a number of small pen factories, many of them family-run operations or craftsmen's workshops.

Soffer (Italia), c.a. 1940

La Soffer era prodotta a Settimo Torinese, città vicino Torino. Settimo Torinese era sede di numerose piccole fabbriche di penne, molte delle quali a conduzione familiare e artigianale.

Penco (Italy), 1930-50

Two celluloid fountain pens from the 1930s and a pen and pencil set
from the 1950s in its original case.

Penco (Italia), 1930-50

*Le penne presentate sono due stilografiche in celluloide degli anni '30
e un set con l'astuccio originale degli anni '50.*

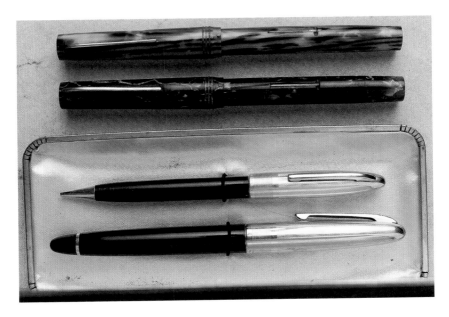

Soffer, 1940-50: Gray
laminated pen sold as a
souvenir of Rome.
Wilmas, Dacis, and Estense:
Three Italian pens from
the 1940s in mother-of-
pearl celluloid, intended
as First Communion gifts.

Italia, 1940-50

*Soffer 1940-50: Penna
grigia anellata venduta
come ricordo di Roma.
Wilmas, Dacis e Estense:
Tre penne anni '40 in cel-
luloide color madreperla
per 1° Comunione.*

United States and Italy, 1910-20

A group of gold-filled mechanical pencils, decorated
in the filigree style.

Stati Uniti e Italia, 1910-20

*Serie di portamine in metallo laminato oro e deco-
razione in filigrana.*

\mathcal{V}arious metal and celluloid mechanical pencils.

Vari portamine in metallo o in celluloide.

Italy, 1940s

Italianissima, with glass nib produced under the national self-sufficiency program. Ital, a side-filling fountain pen. Contessa, with gold-filled partial overlay.

Italia, anni '40

Una Italianissima con pennino autarchico in vetro. Una stilografica Ital con carica-mento laterale. Una Contessa in parte laminata oro.

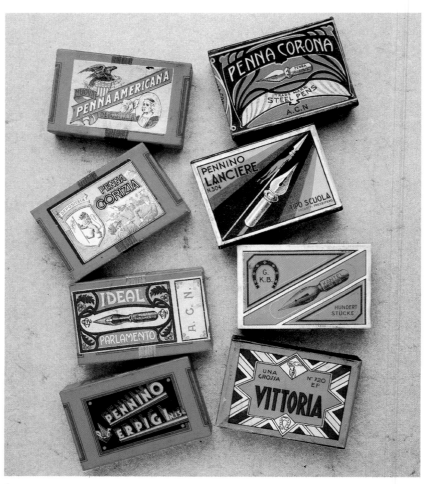

\mathcal{V}ariety of nib boxes, ca. 1920–40.

Vaerie di scatole di pennini anni 1920-40.

The Fountain Pen

*T*he history of the pen is intimately linked to the evolution of writing down through the ages in different parts of the world. Scribes in the time of the pharaohs used papyrus styli, which produced a broad stroke similar to that of a brush. The Assyrians and Babylonians wrote with little pointed reeds on tablets of fresh clay. The Greeks and Romans used pointed stalks of various sturdy grasses or rushes, with a slit down the middle of the point, to write on parchment or papyrus. Sometimes they also wrote on waxed tablets, for which they prepared suitable styli.

In the seventh century, people began using birds' feathers, especially goose quills. These were followed by a vast assortment of sticks or thin tubes in any number of materials, with more and more imaginative tips, until in 1783 a Leipzig craftsman invented the first nib pen: a sliver of goose quill attached to a horn or bronze shaft.

The nineteenth century saw the invention of a great many nibs, in odd shapes and the most disparate materials. Finally, with the development of the steel industry, metal pens came into production, yet the metal point was quite stiff and lacked the necessary flexibility. It was only around 1820 that John Mitchell and Joseph Gillott developed more flexible nibs, and their ideas were developed further by Josiah Manson, considered the true father of the modern nib. He produced a nib that would later be patented, in 1830, by James Perry: the point was no longer cylindrical, but had a gently curved cross-section with a hole at the end of the slit; a number of lateral cuts made the nib flexible and channeled the ink flow. The next step was to find materials that could withstand the corrosive effects of ink better than steel. Diamond, glass, and porcelain nibs were tried, but it was only with the use of gold (reinforced at the tip with osmium-iridium or rhodium), that a truly flexible nib was developed.

In 1809, F. B. Fölsch made the first pen with a reservoir, nib holder and capsule, and steel nib. In addition to this modest though innovative attempt, the nineteenth century saw the submission of over one hundred patents, all more or less viable, but all with some defect in the ink-supply system.

It was not until 1884 that the problem was solved in a patent by the American L. E. Waterman, inventor of the first truly workable ink feed. Four years later, the Parker Pen Company was founded in Janesville, Wisconsin and the company immediately showed its strength

as an innovator with the Lucky Curve feed system, which had an ingenious "duckbill" curve that kept the ink from dripping out when you opened the cap and used the pen. But the man responsible for the greatest advance in the pen that Waterman had invented was Roy Conklin, who in 1898 invented the first built-in filler system: the Crescent Filler with its characteristic half-moon, which doomed the eyedroppers that had been used to fill pens until that time. The first patent for a lever filling system, by Walter Sheaffer, dates from 1908; this system consisted of a rubber sac that drew in ink as it was inflated and deflated by means of a thin metal rod inside the barrel.

The turn of the century saw the founding of the other great corporate names in the history of the fountain pen. In America there was not only Waterman, but Parker, Sheaffer, Conklin, Wahl-Eversharp, and John Holland; in Germany, Montblanc and Pelikan; in England, Conway Stewart, De La Rue-Onoto, and Mabie Todd with its famous Swan brand; and in Italy, Aurora and Omas. These and all other pen manufacturers shared the goal of not only making their pens ever safer, cleaner, and more practical, with supple and flexible nibs, but beautiful and desirable, as well: status symbols for the successful businessman. Fountain pen companies carried on a continuous search for new filling systems; for new and better nibs in various shapes and various alloys; for new barrel materials such as bakelite, celluloid, casein, hard rubber, galalith, overlays of gold, silver and lacquer; and finally, for a variety of colors and patterns.

It was not until the early 1920s that the fountain pen achieved a height of popularity and reliability. Throughout the twenties there was a real boom in fountain pens—a boom that died away in the Depression of the thirties, which gradually forced many fine manufacturers to shut down after 1937. Shapes and materials grew simpler and, of necessity, production was cut back. World War II, with its destruction and its aftermath, was followed by a slow recovery and, finally, the great comeback of the fountain pen, as collectors began seeking vintage pens. Now, after the dark ages of the Bic, even in the age of computers and printers, people are again seeking out this magnificent implement with its elegant, personal touch.

Manufacturers

WATERMAN (UNITED STATES)

The story of the founding of the leading maker of fountain pens in the United States, and perhaps in the world, sounds like the plot line of a typical Hollywood movie. The young insurance salesman Lewis E. Waterman was about to close an important contract. But when the moment came to sign, ink poured out of his fountain pen, ruining both the document and his deal. He then decided to construct a fountain pen that would never cause such problems again. The result of his efforts was the Ideal Pen Company, founded in New York in March of

1884. Until around 1920, production focused on not only hard-rubber pens but pens with precious-metal overlays: gold, silver and gold filled. The company enjoyed great success; Waterman was selling a thousand pens a day in 1901, and by the golden age of fountain pens in the twenties, the company was selling millions of pens a year.

In 1923, the Ripple series was introduced, made of marble-patterned hard rubber in a wide variety of colors and sizes. In 1929 came the Patrician, the first celluloid pen, with its companion Lady Patrician and No. 94 lines. The Ink Vue came out in 1935, and the Hundred Year in 1939. In 1954, the declining market for fountain pens forced Waterman to cease production in America, and the company was transferred to the French company Gillette.

PARKER (UNITED STATES)

*G*eorge Parker, a teacher at a telegraphy school in Janesville, Wisconsin, started his career in the world of fountain pens by repairing his students' pens. In 1888 he built his first pen, which he patented on December 10, 1889. In 1892 came the patent for the Lucky Curve.

Between 1900 and 1915, Parker produced a series of extremely beautiful gold and silver pens. Among the memorable—and very rare—examples were the Silver Snake, Aztec, Indians, and Swastika. In 1921 the Duofold series was introduced, with the famous Big Red, a pen that broke away from tradition. It was large, with an impressive gold nib

and a red-orange color that contrasted sharply with the monotonous black or red and black hard-rubber pens then in use. The price was equally substantial: seven dollars.

In 1926, the company started manufacturing celluloid (Permanite) pens, which offered a broader range of colors. In 1933 came the innovative Vacumatic model, which eliminated the internal rubber ink sac, thus offering a larger ink capacity. Around this time the "arrow" clip that is still the symbol of Parker pens was also adopted.

The year 1941 saw the introduction of the No. 51, advertised as "the pen ten years ahead of its time." Its design was a fundamental innovation over conventional fountain pens, and would be the benchmark for the pens of the 1950s.

SHEAFFER (UNITED STATES)

\mathcal{W}alter A. Sheaffer was a jeweler, with a store and workshop in Fort Madison, Iowa. A passionate fountain pen enthusiast, he designed the side-lever filling mechanism in 1907. He patented it in 1908; in 1912, he began producing pens on his own, using his own simple, reliable patent. He scored an immediate hit, and Sheaffer pens soon became widely known.

In 1920 came the Lifetime series, which was guaranteed for life against any kind of mishap. This pen became one of the most important status symbols of its day. In 1934, Sheaffer introduced a plunger filling

system that eliminated the rubber sac. The tubular Triumph nib dates from 1942, and 1952 saw the introduction of the Snorkel system, used until 1960 and beyond in the PFM (Pen for Men), the large fountain pen that would typify Sheaffer's production in the sixties.

WAHL-EVERSHARP (UNITED STATES)

*I*n 1914, the Wahl Adding Machine Company, an industrial investment company, acquired the Eversharp Pencil Company as a way of entering the market for writing instruments. Eversharp had been founded by Tokuji Hayakawa, who invented a special mechanism for mechanical pencils.

Wahl went on producing metal pens and pencils, along with hard-rubber pens, until 1927. In 1928, well after the rest of the major American pen manufacturers, the company began producing a celluloid pen, the Personal Point. A little gold circle, the Gold Seal, marked the most prestigious line.

In 1930, Eversharp bowed to new tastes and modified its pens into a rounder shape. The new line was called Equipoised. In 1931 came the Doric, a twelve-faceted Art Deco pen that would remain in production until 1941. The company brought out its last great success in 1941: the Skyline. Later models—the Fifth Avenue, the CA ("capillary action") ballpoint, the Symphony—met with a lukewarm response from the public. In 1957, Eversharp sold its writing-instruments division to Parker.

CONKLIN (UNITED STATES)

The Conklin Pen Company was founded by Roy Conklin in Toledo, Ohio, in 1898. Its first pen was the Crescent Filler, which the company patented in 1901 and continued to make until 1928. It had an unusual filling mechanism: a metal crescent protruded from the body, and was pushed to draw up the ink. The Endura line was launched in 1924, and the Symetrik line in 1930. In 1932 came the Nozac. Some of its models had a transparent body with a graduated gauge to show how much ink was left in the barrel. Faced with economic difficulties, Conklin ceased production in 1938.

MONTBLANC (GERMANY)

This company was founded in Hamburg in 1908 as the Simplo Filler Pen Company; it sold models called the Simplo, Rouge et Noire, and Diplomat. These were eyedropper-filled, or "safety," models, made of black or red hard rubber. The tip of the cap was red or white.

The name Montblanc was first used in 1911, and the cap tip was made in white only. A few years later came the six-pointed star, the company's distinctive insignia.

In 1924, production was divided into several lines of different quality. The top of the line, called the Meisterstück (Masterpiece), had a gold and platinum nib engraved with the number 4810, the height of

Mont Blanc in meters. The Meisterstück has been produced without interruption down to the present day, with very little change in its design.

This trademark was registered in Hanover in 1878 by Gunther Wagner, a wealthy manufacturer of inks and paints, and was taken over near the turn of the century by his son-in-law, Fritz Beindorff. Throughout the early part of this century the company was still producing mostly paints and inks. Not until 1929 did it patent its first fountain pen, the No. 100, an attractive, innovative pen with a plunger mechanism, a partially see-through barrel, a special "conal" ink feed, and a gold nib with an osmium- and iridium-reinforced tip. This would serve as the basic model for all Pelikan pens for more than thirty years. Almost all had a green barrel and a black cap.

In 1931, two gold-plated bands were added to the cap. The year 1932 saw the introduction of the No. 110. In 1934 came the Pelikan No. 111 T, the rare, famous, and highly prized Toledo, decorated with an elegant pelican motif. In 1935, the company introduced new barrel colors: tortoiseshell, gray marble, and lizard green. In 1938, the No. 100 N line came on the market, with a larger barrel and nib and various modifications in its mechanism. The No. 400, No. 500, No. 600, and No. 700 lines produced since the war have all been modern versions of the No. 100.

MABIE TODD
(UNITED STATES AND ENGLAND)

The Mabie Todd Company opened for business in New York in 1843 as a manufacturer of pen points and pen-point holders. In 1880, it developed a refillable pen that at first came with a needle-point nib (a "stylographic" pen) and later with a conventional nib. In 1908 the company was sold to an English businessman named Watts, and until 1920 production remained divided between the United States and England. The Swan was the most important line, followed by the Swallow and the Blackbird. Production ceased in the late 1950s.

CONWAY STEWART (ENGLAND)

This English company was founded in 1905 and specialized in moderately priced pens. The most important lines were the Duro, the Dinky, and the Dandy.

AURORA (ITALY)

Founded in 1919 in Turin by Isaia Levi, the Fabbrica Italiana di Penne a Serbatoio Aurora (Aurora Italian Reservoir-Pen Factory) was the first major Italian manufacturer in the industry, and the first to earn an international reputation. In 1925 the Internazionale was created, a very beautiful lever-filling fountain pen sold in four versions

(No. 25, No. 30, No. 45 and No. 50), with an impressive gold nib and a celluloid body available in a variety of colors or with a gold-filled overlay.

In 1929, the company's industrial operations underwent a complete restructuring. Two new brands were created, the Olo and the Asco. The first was a low-cost line, while the second was designed for corporate gift-giving or as promotional giveaways. In 1930 the company created the Novum, an exquisite cylindrical pen in a round or ten-faceted format, equipped with a new filling system that used a lever on the barrel end, and topped off with an original anti-theft safety clip. It came in three sizes.

In 1934 and 1935, the company brought out its two most famous pens, the ones most highly prized by collectors: the Asterope and the Etiopia. The Asterope used the same filling system as the Novum, but instead of having a classic cap, the nib was enclosed inside a cylinder with a spring lid that opened by moving a slider along the pen barrel. It came in black, gold marble, gold and black, and green and turquoise marble. The Etiopia, in four colors (ivory, red, green, and gray-violet) was best known for the ivory-white version made for the Italian Armed Forces in Ethiopia. The rest are all but impossible to find; only two known examples of the green version exist. The model was decorated with a Roman eagle engraved on the cap, with the inscription "Etiopia" and a wide Greek key motif. It was eyedropper filling, with ink made by adding water to soluble ink granules contained in the barrel, which could be opened by unscrewing the end.

The factory burned down during the war and production did not resume until 1947, at the new Strada Abbadia di Sutra factory. The first postwar model was the famous No. 88, designed by Marcello Nizzoli and available in two versions with different caps and a hooded gold nib, with no less than seventeen kinds of points and two levels of flexibility.

O M A S (I T A L Y)

*O*fficially established in 1925, Omas (Officine Meccaniche Armando Simoni) had actually been in business since 1919. It patented its first pen in 1927. This company, which shares with Aurora the distinction of being the most important of the Italian manufacturers of classic pens, was the creation of Armando Simoni, who was born near Bologna in 1891. His first patent was for an original lever-filling reservoir pen that incorporated a thermometer. It was called the Doctor. But the first really important Omas was the Omas Extra of 1932. Made of celluloid, with a sphere clip, in four sizes and in ten wonderful colors with a unique arabesque pattern, it had a soft and springy nib and was a real status symbol in prewar Italy.

The next patent, the Omas Lucens of 1936, would be the Bolognese company's most illustrious success. With a transparent barrel and an innovative plunger filling mechanism, sacless and springless, and thus with a larger ink capacity, it came in a round and a faceted version, in a number of different sizes and colors. Because of its exceptional success it became known as "the diamond of fountain pens" and

"the flagship." The success of the Lucens line was sustained by later modifications to the arrow-shaped clip and to the nib, which because of the national self-sufficiency program was no longer of gold but of the Italian-made alloy called permanium.

After the war, Omas brought out the No. 361, which had an innovative nib, rotation-mounted at the center of the pen, that could write in any position desired, with a stiff or flexible stroke. This pen kept the company among the top manufacturers both in Italy and abroad until the late fifties. Armando Simoni died in 1958. Though the historic era of Officine Meccaniche Armando Simoni was over, the new Omas was still vigorous and in the vanguard—where it remains today.

ANCORA (ITALY)

Founded in 1909 by Giuseppe Zanini at Sesto Calende on Lake Maggiore, this was Italy's oldest fountain pen factory. After a move to a new location in Arona, it remained in business until 1975 under Alfredo Zanini, who took over after his father died in 1929.

COLUMBUS (ITALY)

Founded by Eugenio Verga in 1922 as a small-scale producer of fountain pens based on American and English originals, the company went into full production in 1927 with its first patent. In the thirties its most important model was the Columbus Extra, with an original

internal-lever filling mechanism. The factory was destroyed in the war, but was rebuilt and started up production again with a series of large, medium, and women's models called the No. 134, No. 132 and No. 130.